IMAGES
of America

CUNEO MUSEUM AND GARDENS

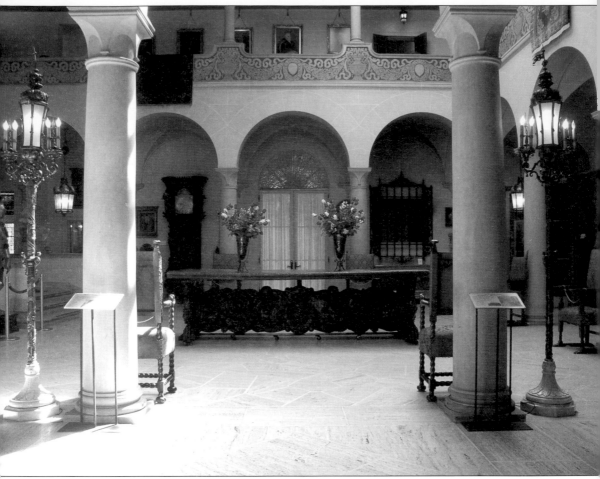

Visitors receive an impressive introduction to the beauty of the Cuneo Museum when they enter the great hall, an arcaded courtyard with a 30-foot skylight. A grand staircase, stained-glass doors, and columns of Indiana limestone are some of the architectural features in the hall. Antique furniture and artwork fill the impressive space with color and interest. (Cuneo Museum.)

On the cover: Abundant flowers grow at the feet of an elegant lady in the Cuneo garden. The home and grounds were constructed at a time when European forms of architecture were considered emblems of good taste and cultivation. Formal plantings, statuary, and stone balustrades re-create the Old World charm of an Italian villa. (Cuneo Museum.)

IMAGES
of America

CUNEO MUSEUM
AND GARDENS

John B. Byrne

ARCADIA
PUBLISHING

Published by Arcadia Publishing
Charleston SC, Chicago IL, Portsmouth NH, San Francisco CA

Printed in the United States of America

Library of Congress Catalog Card Number: 2008929803

For all general information contact Arcadia Publishing at:
Telephone 843-853-2070
Fax 843-853-0044
E-mail sales@arcadiapublishing.com
For customer service and orders:
Toll-Free 1-888-313-2665

Visit us on the Internet at www.arcadiapublishing.com

For Susan, Alanna, and Moira

CONTENTS

ACKNOWLEDGMENTS

The Cuneo archive contains a treasure trove of historic photographs, but to recount a reasonably complete history of the Cuneo estate required material from many other sources. I would like to thank my colleagues in other museums and archives for their help in acquiring additional photographs for the book.

Most of the Insull family photographs came from the Samuel Insull Papers at the Loyola University Chicago Archives. Kathy Young and her assistant Rebecca Hyman were most helpful in locating photographs and finding copyright holders. The kind ladies of the Libertyville Historical Society—Audrey Krueger, Janet Aemisegger, Ruth Buehrer, and Faith Sage—put up with me in their cozy basement for several days while I scanned photographs of the Libertyville area. Diana Dretske of the Lake County Discovery Museum, Susan Hall of the Lake County Forest Preserves, and Jim Holland provided the photographs of the Adlai Stevenson home. Arthur Miller of the Lake Forest College Library and Alice Arlen of the Patterson family granted permission to use the photographs of the Pattersons. Michael T. Steiber of the Morton Arboretum granted permission to use the photographs of Jens Jensen. Valerie Harris of the University of Illinois at Chicago provided images of Hawthorn children's tours. David Kapella of the Brinks History Museum supplied the image of John D. Allen. Larry Plachno, editor of *The Memoirs of Samuel Insull*, kindly allowed me to use quotes from his book. Carla Belniak, daughter of Carl Snyder, Cuneo's wonderful publicist for Hawthorn Mellody, sent me some great family photographs. George Kufrin allowed me to use his publicity photographs. Unless otherwise noted, images are courtesy of the Cuneo Museum.

I would also like to thank John Cuneo Jr. and Pam Adams, director of the Cuneo Museum, for supporting the project. Thanks to the Museum staff—Mary Cook, Sharon Ossowski, Brian Keena, Stan Serkowski, and Bob Probst—for their stimulating, good-natured harassment.

Finally I would like to thank Jeff Ruetsche, John Pearson, and Arcadia Publishing for their understanding during a difficult time.

INTRODUCTION

The Cuneo Museum is a distinguished survivor from an era of great country estates in Lake County, Illinois. The open fields and small farms south of Libertyville at one time must have seemed an unlikely setting for the posh palaces of wealthy urban businessmen. Until the early 1900s, the settlement pattern was typical of the area. An 1885 plat of Libertyville Township reveals a dense patchwork of small family farms. Photographs of the village from the same period show the usual rows of shops framing an unpaved main street. The area hardly looked like a potential retreat for the rich and famous. The big city was not far away, however, and it had started to exert its gravitational pull. Two train lines ran from Chicago to Libertyville by the early years of the 20th century and the automobile was replacing the horse as the common means of transportation, making commuting time to the city somewhat more convenient. Chicago's robust business climate provided an opportunity for men of ambition, energy, and talent to build commercial empires in new industries. They amassed substantial fortunes, and these new millionaires began to look for property large enough to indulge their personal fantasies of domestic splendor.

They found what they were looking for north of the city in eastern Lake County. The area became one of the most luxurious private residential neighborhoods in the country, a kind of Hamptons among the cornfields. What is now the Cuneo Museum and Gardens had its origin in that period. To provide geographical and historical context, photographs of five neighboring estates are presented in the first chapter. The owners of these properties were among the most successful businessmen and politicians in the city.

In 1904, John Thompson built what was to become Red Top Farm south of the village on the east side of Milwaukee Avenue. Thompson owned over 100 cafeteria-style restaurants in cities around the country. He joined a gentlemen's trotting club and developed an interest in breeding and racing horses. He built the Libertyville property as a summer home for his family and as a stable for his horses. Red Top was later owned by Irving Florsheim of the shoe manufacturing family and by Walter Mullady whose business was cartage and banking. They used the house as a more permanent residence, but followed Thompson's precedent by using the farm to raise racehorses. The estate's name came from the fireproof roofing materials on all the farm buildings, which were only available in red. Two years later, Joseph Medill Patterson built a mansion a little further south on the opposite side of Milwaukee Avenue. Patterson was grandson to Joseph Medill and cousin to Col. Robert R. McCormick, of the *Chicago Tribune*. Patterson was in the family newspaper business as well, but he ran afoul of the *Tribune*'s management because of his socialist politics. He retreated to his Libertyville estate to learn farming and to write books and

plays exposing the foibles of the idle rich before returning to the newspaper as president. His property straddled both sides of Milwaukee Avenue along Route 59A, now Route 60. Stuart Harvey's mansion was between the Cuneo estate and Patterson's mansion. Stuart was the grandson of Fred Harvey, who established restaurants and hotels along the Atchison, Topeka and Santa Fe Railway and staffed them with the famous Harvey girls, recruited in eastern cities to bring a refinement to service still missing in rough western whistle-stops. Across Route 59A, John Allen, the chief executive officer of Brink's Express Company, bought 342 acres and remodeled a farmhouse in 1938 to create his estate, which he called Allendale. Also in 1938, Adlai Stevenson, the politician known as "the man from Libertyville," bought property further west on St. Mary's Road and created a rustic retreat for his family. Stevenson's is the only other home left standing besides the Cuneo mansion.

Most of these men already had luxury homes or apartments in the city, which were conveniently close to their places of business. Their country homes served other purposes. The readily available land was a blank canvas on which to paint the perfect living space. In the open fields, there was room for mansions, gardens, parks, ponds, stables, and farms. In a few instances, the owners remodeled existing farmhouses, but in most cases, they hired talented architects and landscape designers to build literally from the ground up. The residential style reflected the owner's preference. Thompson's mansion, with its white, pillared portico, looked like an old Kentucky home, Patterson's home was a stately Georgian affair, while Insull built himself a pink Italian palazzo. Besides providing a grandiose setting to inhabit, these magnificent estates were social showcases. These were sober men of business, and there were no endless Gatsby-like bashes, but homes like these were made to show off. The Thompson family hosted Sunday country dinners, Allen held corn roasts for thousands of guests to raise funds for the opera, and the Cuneo family hosted a New Year's Eve banquet every year that was followed by a first-run movie in the basement theater. When the parties were over, these country estates provided a quiet retreat from the urban hustle of business. The natural setting and the simple tasks of farm life provided an antidote to the pace and pressure of business and politics. Adlai Stevenson took a break from being governor to walk his fields and feed the sheep, Patterson saw farming as a purifying form of work, and Insull was sure that the requisite outdoor activity kept him in good health. The level of farming activity varied from estate to estate. The residents of Red Top confined themselves principally to the gentlemanly pastime of raising horses for sport. Patterson farmed seriously for a brief period, and Allen raised champion stock. For Insull and Cuneo, a full range of farming activities was an essential part of their country lifestyle. They used their substantial resources to implement the most modern methods and, Cuneo, with his multimillion-dollar dairy and poultry operations, transformed a farming pastime into a profitable enterprise. These country estates, then, were stylish family homes, elegant social settings, rustic retreats, and working farms all in one.

These wealthy residents changed the character of the landscape with their beautiful homes and lent the prestige of their names to the township, but two of them in particular had a great influence on the community, Samuel Insull and John Cuneo Sr. The extent of their property, the length of their residence, and their engagement in local business and community life left a lasting imprint on the area.

Samuel Insull was born in London into modest circumstances. His father was a dairyman and temperance crusader; his mother ran a boardinghouse. Insull started work at 14, and eventually took a job with Thomas Edison's representative in London. An Edison engineer from America recognized Insull's talent and recommended him to Edison as a private secretary. In 1887, at 21, Insull came to America to work with Edison himself. His tireless energy matched Edison's and his financial acumen helped keep the inventor's many projects supplied with capital. Edison put Insull in charge of the electrical equipment manufacturing plant in Schenectady, New York, that eventually became General Electric. When Edison retired from the business, Insull came west to take over Chicago Edison, which he merged with other small companies to create Commonwealth Edison. Insull pioneered central station power generation at the Harrison and

Fisk Street stations in Chicago. In his Lake County Experiment, he worked out the technology and rate structure that allowed for the first successful electrification of rural areas. Insull bought numerous smaller power plants until his companies supplied electricity to 5,000 communities in 32 states. He also rescued the struggling People's Gas, Coke and Light Company, and, as chairman of the Chicago Rapid Transit Authority, he ran the electric streetcars and the elevated trains. Completing his dominance of traction and power, he acquired the electric interurban lines—the Chicago, North Shore and Milwaukee Railroad; the Chicago, South Shore and South Bend Railroad; and the Chicago, Aurora and Elgin Railroad. Undoubtedly, he was the preeminent business figure in Chicago in the 1920s.

To finance his operations, Insull marketed his securities to hundreds of thousands of investors, and to protect his control of his companies, he created complex layers of holding companies. This highly leveraged structure left him in a vulnerable position when the Depression dragged on, and in 1932, his debts overwhelmed him and he lost everything, including the Libertyville property. He retired to Paris, but the Franklin D. Roosevelt administration targeted him as a predatory agent of the Depression, and investors ruined by the Insull collapse raised an outcry condemning him. Criminal charges were brought against him in Chicago. He fled to Greece, but after a year of legal wrangling, he was captured and returned for trial. He was exonerated on three separate charges. His pension was restored and he retired to Paris again. A few years later, he died of a heart attack in a subway station in Paris.

In 1907, Insull acquired the 132-acre Barr farm, his first land in Libertyville. Originally, he remodeled the Barr farmhouse for his family's use, but in 1914 he hired architect Benjamin Marshall to build the ornate mansion that survives today as the Cuneo Museum. A precocious talent, Marshall had little formal training, but had earned a partnership in the firm of Marshall and Fox. He was fascinated by the neoclassical style of the 1893 World's Columbian Exposition, and his major projects were luxurious public buildings like the Edgewater Beach, the Drake, and the Blackstone Hotels. Insull also hired prairie-style landscape architect Jens Jensen to redesign the grounds. A Danish immigrant, Jensen started working for the Chicago Public Park District and designed private estates for the likes of Insull and Henry Ford. The new mansion and its beautiful park and gardens were finished in 1916.

After Insull lost his property, it was divided and sold to satisfy some of Insull's debts. In 1937, John Cuneo Sr. purchased the 100 acres with the mansion and major farm buildings for a reported $752,000. He acquired the option for an additional 800 acres of farmland. Later, as some of his prominent neighbors moved away, he purchased their estates and his property grew to more than 2,000 acres. Cuneo came from an established Chicago family. His grandparents came to Chicago from Genoa, Italy, in 1857. Giovanni and Caterina Cuneo owned a grocery store and a small farm in the city, and they invested in real estate. Their son Frank founded a produce company called Garibaldi and Cuneo in the South Water Street Markets. He also developed commercial real estate, including the Wilson Avenue business district.

The family was affluent and well established by the time of John Cuneo Sr.'s birth in 1884. He was sent to Yale University, and it was expected that upon graduation he would enter the family business, but he was impatient with school and anxious to try his mettle in the real world. He left Yale and, at his father's insistence, found his own job. He worked in a bookbindery and learned the details of the trade. Within a year, he borrowed $10,000 from his father to buy his own bindery. After acquisitions and mergers, his business grew into the Cuneo Press, at one time the largest printing operation in the country.

In 1971, John sold 590 acres along Route 60 between Milwaukee Avenue and Butterfield Road to the developers of Hawthorn Mall and New Century Town. The town government of Libertyville balked at accepting the development, so the property was annexed by the Village of Vernon Hills. When John died in 1977, the farm property surrounding the estate was in trust to the Cuneo children. Much of that property has been developed as Gregg's Landing. Libertyville Township once again resisted the development, so the west side of Milwaukee Avenue was annexed to Vernon Hills. The land that used to be the grand estates of the gentlemen farmers

have split with Red Top going to Libertyville while all the others are now part of Vernon Hills. This is why the town boundaries south of Libertyville divide along Milwaukee Avenue.

In 1977, John Cuneo Sr. died. He left his house and part of the estate to his wife Julia with the instructions that at her death, the mansion and gardens were to be preserved as a museum under the management of the Cuneo Foundation. John Cuneo Jr., president of the Cuneo Foundation Board, directed the building of a new tropical plant conservatory and a peacock house. The rose and formal gardens and the white fallow deer pen were also rebuilt before the museum officially opened to the public in 1991. Today the Cuneo Museum offers guided tours of the mansion and presents concerts, theater, car shows, art festivals, and special holiday events.

One

THE GENTLEMEN FARMERS

The gentlemen farmers transformed the area south of Libertyville from small homesteads to baronial estates, from small frame houses surrounded by cornfields to palaces and manor homes ringed by parklands and gardens. They settled in two waves. John Thompson, Joseph Medill Patterson, and Samuel Insull built their estates in the first years of the 20th century. Insull continued to acquire land, and by the late 1920s, he had accumulated over 4,000 acres. In 1932, when the bank receivers took over the Insull property, they wanted to sell the land as quickly as possible. Adlai Stevenson, John Allen, Irving Florsheim, and John Cuneo Sr. purchased their estates at this time, and Joseph Medill Patterson expanded his property.

As suggested in the introduction, these men used their country estates in different ways. The most famous resident, Adlai Stevenson, lent the prestige of his name to Libertyville, but was able to use his estate only as an occasional retreat. Thompson built his mansion as a summer home, but his successors, Florsheim and Walter Mullady, lived at Red Top year-round. Mullady raced his thoroughbreds with great success at the Arlington Race Track, which was owned in part by John Allen. Allen applied his business savvy to his farming, especially in stockbreeding. When he retired and moved away in the 1950s, he allowed the Sisters of Charity to use Allendale as a home for elderly women. The Harvey estate was not a farm at all, but seems to have been used for hunting and fishing. Patterson used his country estate in part as a writer's retreat. After Patterson moved east to establish the *New York Daily News* in the 1920s, his daughters took over the property. Josephine ran a pig and dairy farm on the northeast corner of Routes 60 and 21 until she sold the land to Cuneo. The Mellody name that originated with the Armour farm in Lake Forest may have come to Hawthorn Farm through this transaction. With the exception of Stevenson's home, all these properties are now the site of commercial or residential developments.

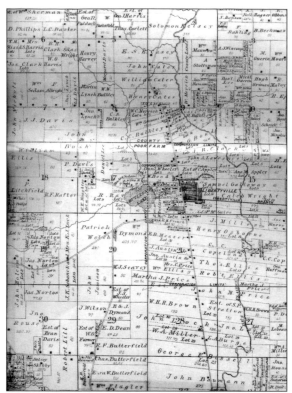

This 1885 map of Libertyville Township properties shows the patchwork of small farms one would expect of a rural area at the time. The town is in the center with Milwaukee Avenue running through the middle from top to bottom. Notice George Bissell (of the carpet cleaning company) in the lower center. He was a pioneer in what would become a full-scale invasion of wealthy urbanites. (Libertyville Historical Society.)

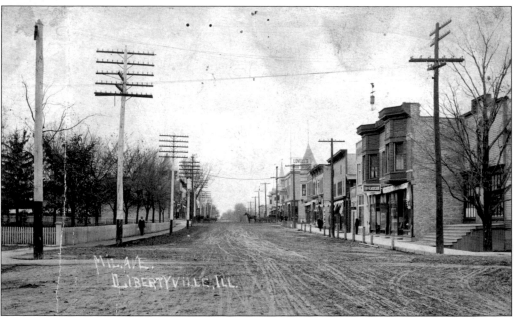

Libertyville in 1900 was typical of small Midwestern towns. It was more developed than villages in the heartland away from the cities, but the two-story buildings, with a storefront below and rows of windows in the rooms to let above, was a familiar main street pattern. The town's development would be influenced by the entrepreneurial energy of the gentlemen farmers who would soon settle nearby. (Libertyville Historical Society.)

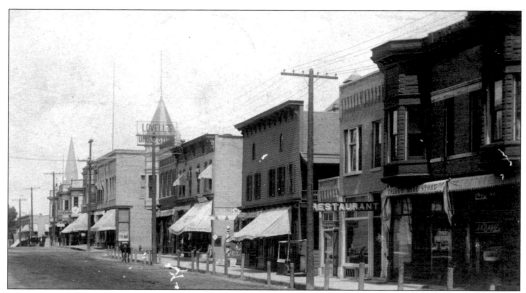

Looking nothing like the haven for the rich it was about to become, by the early 1900s Libertyville had nevertheless established important links to its urban neighbor. The Chicago, Milwaukee and St. Paul Railroad (the pacific extension came after 1905) brought its full service to town in 1900. In 1904, the Chicago and Milwaukee Electric Railroad, later known as the North Shore Railroad, built a spur from Lake Bluff to Libertyville. Samuel Insull would eventually own this railroad. (Libertyville Historical Society.)

John Thompson serves customers at one of his restaurants. Seeking opportunity, he came from downstate to Chicago during the World's Columbian Exposition. He walked into a restaurant on State Street because it bore his family name. When he complained about the food, the proprietor challenged him to buy the place and do better. Thompson negotiated the purchase on the spot for $800. (Chicago History Museum, DN-0066845.)

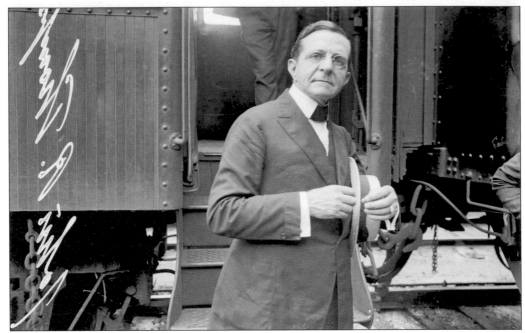

John Thompson's single cafeteria turned into a chain of 100. He became involved in city politics and served as county treasurer. He began driving harness horses as a hobby and joined a "Gentlemen's Driving Club." His name appears often in sports page accounts of trotting races. (Chicago History Museum, DN-0072437.)

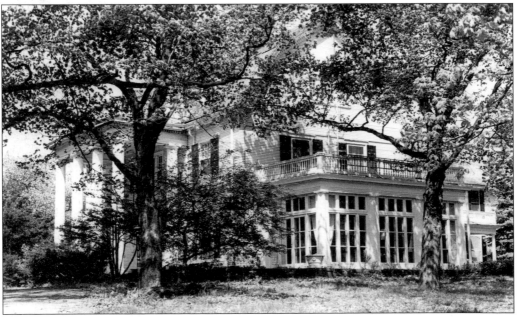

In 1904, Thompson purchased 300 acres in Libertyville to provide his family with a summer home and his horses with a stable and breeding facility. He raced his horses at the nearby Libertyville track. The Thompson family hosted Sunday country dinners, featuring fried chicken and corn on the cob. Thompson remembered crossing the Des Plaines River to pick wild raspberries with his children. (Libertyville Historical Society.)

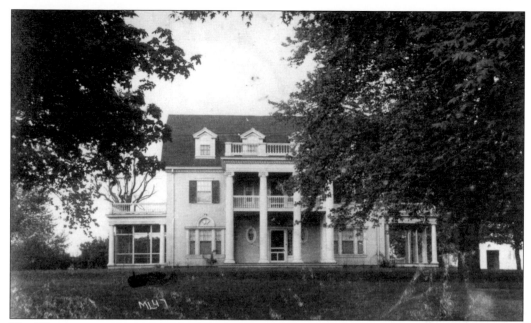

The Thompson mansion was on the northern edge of his property, just south of the village. Unlike the Patterson and Insull mansions, it had a shallow setback and was visible from Milwaukee Avenue. With its white wood frame construction fronted by an impressive pillared portico, the Colonial Revival house could have been a set for *Gone With the Wind*. (Libertyville Historical Society.)

Thompson died in 1927. His property was sold to Samuel Insull. In 1931, as Insull's financial difficulties worsened, the property was sold to Irving Florsheim (pictured at right), president of the famous shoe manufacturing firm. He built a swimming pool and racing track on the farm and raised thoroughbred horses. His racing and saddle horses won numerous awards. (Chicago History Museum.)

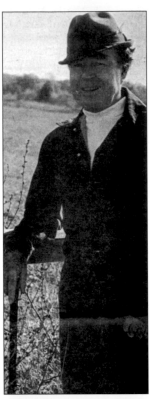

After Irving Florsheim's death, his widow sold the property to Walter Mullady in 1965. Mullady was a Chicago banker and owner of a cartage company. He continued the tradition of previous owners by raising thoroughbreds. Two horses from his stables, Roger's Red Top and Milwaukee Avenue, won regularly in the races at Arlington Park. (Libertyville Historical Society.)

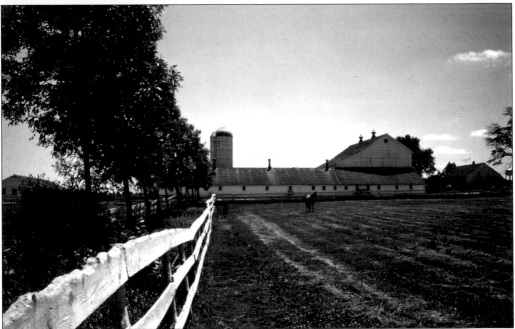

With its Colonial-style mansion, its red-topped barns and outbuildings, and the neat white-plank fence that bordered Milwaukee Avenue and its many horse paddocks, Red Top Farm was perhaps the prettiest and most charming of the estates south of Libertyville. In 1973, Mullady began to sell off parts of the farm for development. (Libertyville Historical Society.)

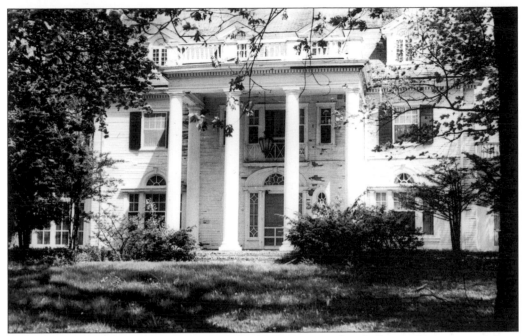

In the following decade, development of the farm property that had once been part of these great estates accelerated. By the late 1980s, some area residents were concerned at the changing character of the township and formed a committee to try and save the deteriorating mansion. The effort was brief and futile. (Libertyville Historical Society.)

The Harvey mansion was just south and west of the Cuneo house. Stuart Harvey, the owner, was the grandson of Fred Harvey, the restaurateur who started fine eateries and hotels along the Atchison, Topeka and Santa Fe Railway. The mansion was at the end of a long drive from Milwaukee Avenue and sat on a slope of land overlooking the Harvey Lake to the west.

Leading to the front door pictured above, the driveway ran close to the present route of Hawthorn Mall's Ring Road. It curved slightly north and ran past fruit orchards on each side. An old-fashioned split rail fence bordered the drive. There was a skeet shooting machine on the edge of the Harvey Lake and a duck blind on the swampy south side.

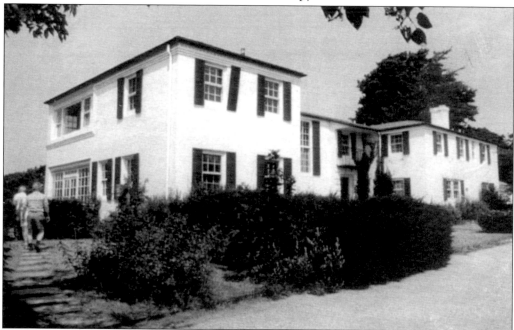

Stuart Harvey sold his property to John Cuneo Sr. in 1956. Consuela, Cuneo's daughter, lived in the mansion with her family before it was rented to three families over many years. During an extended period of vacancy, the mansion started to deteriorate and it was discovered by local youths as a lonely place to party. For safety reasons, it was leveled in the 1980s.

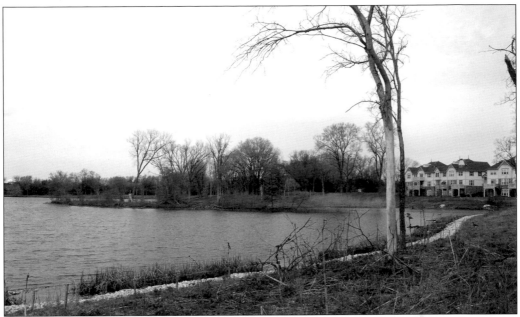

Later the property was sold for residential development. The lake is now in the middle of condominiums. The view in this photograph is from the mansion side of the lake. Arthur Heinson's house was on the north side beyond the narrow point of land. He was John Cuneo's construction boss. His house was moved from behind Hawthorn School across the fields to the Harvey Lake when the mall was developed.

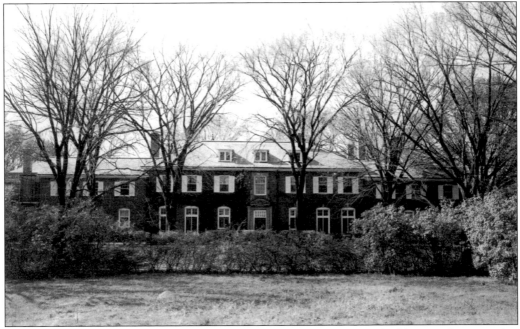

In 1906, Joseph Medill Patterson hired Howard Van Doren Shaw to build a new home on his Libertyville property. The stately redbrick and stone Federal-style mansion was set on a raised terrace one-third of a mile from the road. The farm property straddled Milwaukee Avenue along Route 60. (Harry Swanson and the Libertyville Historical Society.)

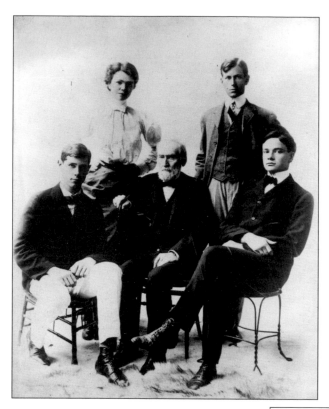

Joseph Medill Patterson was born into an illustrious newspaper family. His grandfather Joseph Medill (center) made the *Chicago Tribune* into "the world's greatest newspaper." His sister Sissy ran the *Washington Times-Herald*. When his mother and aunt were considering selling the *Tribune*, Patterson (right) and his cousin Robert McCormick (left) agreed to run the newspaper in partnership. Another cousin, Medill McCormick is behind Patterson. (Patterson Papers, Lake Forest College Library Archives.)

Patterson was a strong critic of the privileged classes. Early in his *Tribune* career, his political stands caused some conflict. At one point, he retreated to his Libertyville property to farm and write novels and plays about the working classes. Some of the plays he wrote at the farm were produced on Broadway. (Patterson Papers, Lake Forest College Library Archives.)

Patterson served with distinction in World War I. Upon his return to the states, he moved to New York City and started the tabloid *New York Daily News*. Among his contributions to the industry were popular serial comic strips like *Dick Tracy*. He remained nominally connected to the *Tribune,* but he essentially left it for his cousin Robert McCormick to run. (Patterson Papers, Lake Forest College Library Archives.)

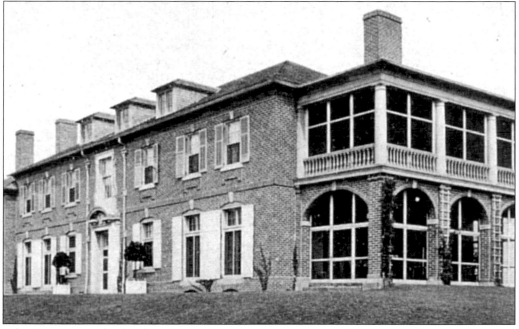

After Patterson's death, the Libertyville property was left to his two daughters, Alicia and Josephine. Josephine actually ran a pig and dairy farm on the southeastern corner of Milwaukee Avenue and Route 59A, now Route 60. The Patterson women sold both parts of the property to John Cuneo Sr. in 1946. (Patterson Papers, Lake Forest College Library Archives.)

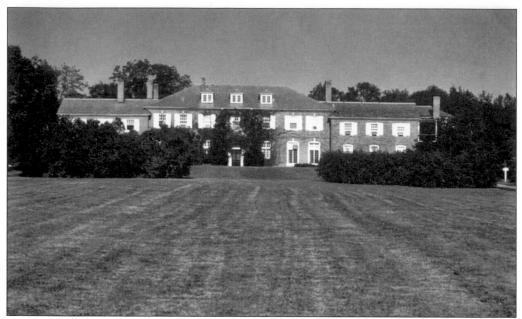

In 1951, John Cuneo Sr. rented the mansion to Hewitt Associates, who moved their offices to the Libertyville site. The company renewed their lease with Cuneo for over 20 years until Hewitt had outgrown the space. Cuneo sold 590 acres, which included the mansion and Patterson land to the west of Milwaukee to urban development for Hawthorn Mall and New Century Town. (Harry Swanson and the Libertyville Historical Society.)

John Allen was chairman of Brinks Express. He bought 342 acres of land on the south side of Route 59A in 1938. Allen remodeled an old farmhouse, built a new barn and swimming pool, and called his estate Allendale. Retiring in the 1950s, he allowed the Daughters of Charity to run a home for elderly women on the property. Fashion Square Plaza now occupies the land. (The Brinks Museum.)

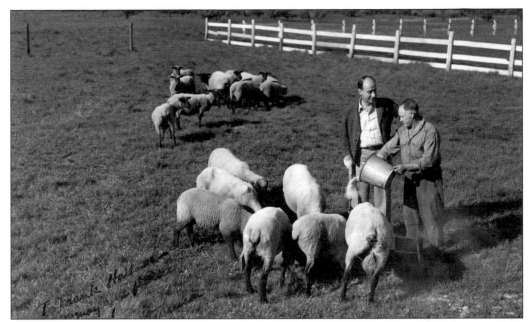

Adlai Stevenson watches his groundskeeper Frank Holland feed the sheep on his farm in 1948. The inscription to Holland finishes "may our flocks increase." Stevenson was governor of Illinois (defeating Dwight Green, Samuel Insull's prosecutor), American ambassador to the United Nations, and twice a presidential candidate. The estate on St. Mary's Road borders the Des Plaines River. (Jim Holland.)

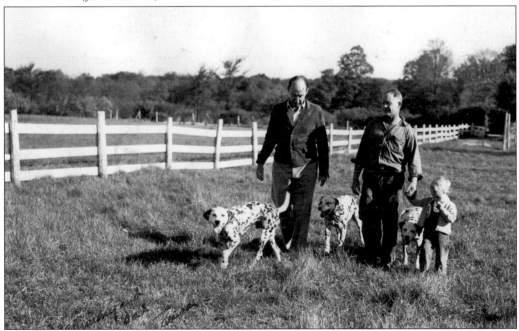

Stevenson walks his dogs with Holland and his son Jimmy in 1948. Stevenson bought the 70-acre parcel of land in 1935 from the creditors of Samuel Insull. The farming activities were light on Stevenson's farm. He used the Libertyville property as a retreat from his high-profile political activities. (Jim Holland.)

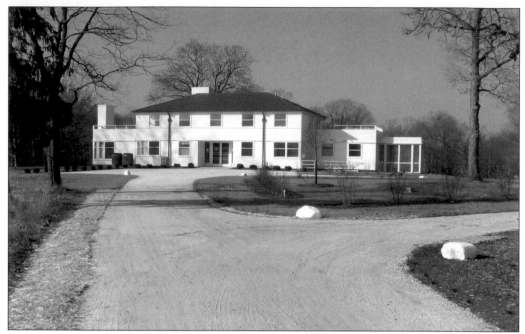

The Stevenson house was approached via a long driveway through parklike landscaping. The grounds plan shows two fields to grow crops to feed the animals, a pasture, orchards, gardens, a service building, and a tennis court. There were bridle trails along the river. (Lake County Forest Preserves.)

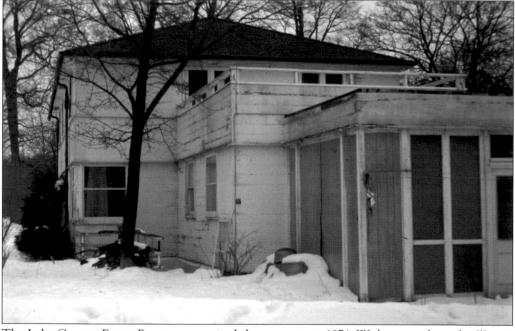

The Lake County Forest Preserves acquired the property in 1974. With grants from the Illinois Historic Preservation Agency and from the "Save Our Treasures" Program, the house and grounds were restored by the Lake County Forest Preserve District to their 1965 condition in 2005–2006. (Lake County Forest Preserves.)

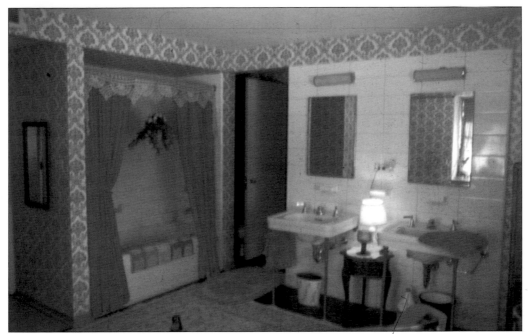

The first photograph shows the bathroom as left by the house's last owner before restoration. The second photograph displays the results after restoration. The Lake County Forest Preserve District decided to use 1965, the year of Stevenson's death, as the historically significant restoration point. They had to gather plans and historic photographs and to conduct interviews to accurately reconstruct the house and grounds. The cost of this arduous restoration process—the grants totaled $2,094,000—and of the continued maintenance of the property in the future explains, perhaps, why so few of the mansions survive from that era of country gentlemen. (Lake County Forest Preserves.)

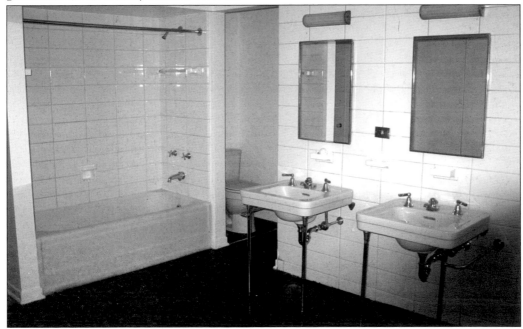

Despite his distinguished political pedigree (his grandfather was vice president) and his intellectual demeanor, Adlai Stevenson was unpretentious with a self-deprecating humor. His mansion seemed to fit his personality. It was spacious and graced with a beautiful setting, but it was simpler in design and certainly less ornate than the homes of several of his wealthy neighbors. (Lake County Forest Preserves.)

The restored beauty of the house and flowering meadow allow one to appreciate Stevenson's love for his country estate. The necessities of business forced the frequent absences of all the gentlemen farmers, and Stevenson's career in national politics allowed him only brief stays at his Libertyville home, enhancing its importance as a quiet retreat. (Lake County Forest Preserves.)

Two

THE RISE AND FALL
OF A POWERHOUSE

Samuel Insull, a pioneer in the electrical industry, was a force field himself. His energy transformed the space around him. In Chicago, his many accomplishments have already been cataloged—he made electric power abundant and affordable, he rescued and made the traction and gas companies efficient and profitable, and he built the opera house. His area of influence around his country home may have been more confined, but his impact was as profound.

His vision for the area was comprehensive and interconnected. He provided affordable electricity to all areas, which made the housing attractive for new residents, and then he built homes. He improved rail travel to make the commute to the city more manageable. He invested in local businesses including banking. He built a school and helped to build a hospital. A Libertyville resident could conceivably live in an Insull house financed through an Insull bank, go to work on an Insull train, and send their kid to an Insull school.

This consolidation of power did not seem to bother the residents. Insull was a man who aroused strong feelings, either positive or negative, and there is no systematic way to measure local opinion from the time. In general, those who saw Insull as an abstraction—as the predatory capitalist that he became in the national media after his fall—loathed him, while those who were closer to him, including his neighbors, admired him. In some of the local newspaper reports, people lament his decline and loss of influence in the village economy, which they saw as beneficial. Even employees on his farm, who were suddenly left without a job, felt more sorrow than resentment for him.

There is no doubt that Samuel Insull played an important role in the growth of the village and of the county while he was a resident. Some of the physical landmarks of his lingering influence are Condell Hospital, the Public Service Building and, the Cuneo Museum and Gardens, which at its core still embodies Insull's vision of the good life.

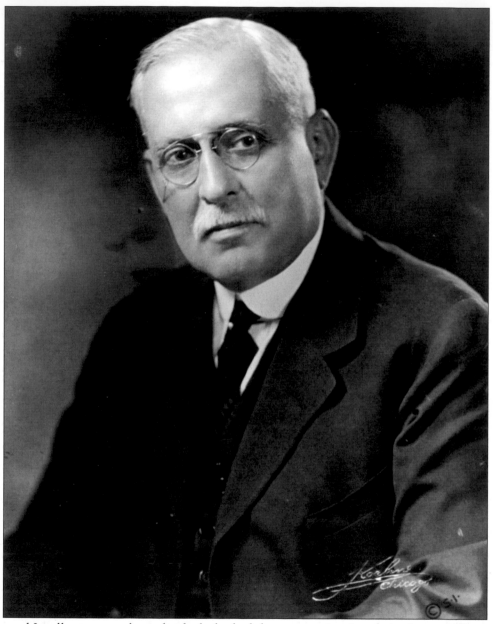

Samuel Insull was a complex individual who had the power to inspire admiration and affection or, especially after his collapse and public disgrace, contempt and outrage. He called himself a man of "positive character." Today he would be called a workaholic, routinely dedicating 16 hours a day to his business. He had confidence in the core principle of capitalism—that an energetic businessman in finding a way to efficiently produce and successfully market a commodity would not only make a profit for himself and his shareholders, but lower the price for his customers and potentially improve the quality of their lives. For many years, his career seemed to embody this principle. Insull and his engineers worked out the technology of central station power generation, the transmission and delivery of that power to a variety of customers over a wide area, and the sophisticated rate structures that made it affordable for the consumer and profitable for the producer. (Loyola University Chicago Archives: Samuel Insull Papers.)

Samuel Insull (standing, second from left) was born in London in 1859 to Emma and Samuel (seated). His father was involved in the temperance movement, and his son characterized him as "a man whose ideals were more in his mind than his pocketbook." He looked to his mother, who encouraged him in his moves to New York and then later to Chicago. (Loyola University Chicago Archives: Samuel Insull Papers.)

Samuel Insull Sr. (standing, first on the right) belonged to this dour national temperance group, possibly the United Kingdom Alliance. While he was their paid representative in Oxfordshire, his sons enjoyed their best years of quality education at a private school in Oxford. After his father lost his position, Samuel Insull left school to take a job at 14. (Loyola University Archives: Samuel Insull Papers.)

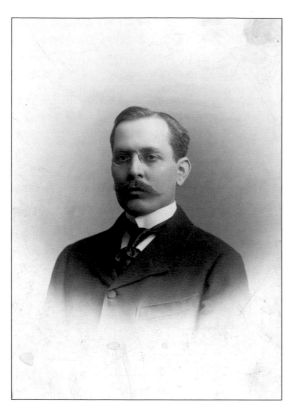

Samuel Insull read with admiration about Thomas Edison in English magazines. He began working for Edison's representative in London. One of Edison's engineers recognized Insull's talent and recommended the young Englishman for the job of the inventor's personal secretary. In 1881, at 21 years old, he assumed his duties and was soon indispensable to Edison. (Loyola University Chicago Archives: Samuel Insull Papers.)

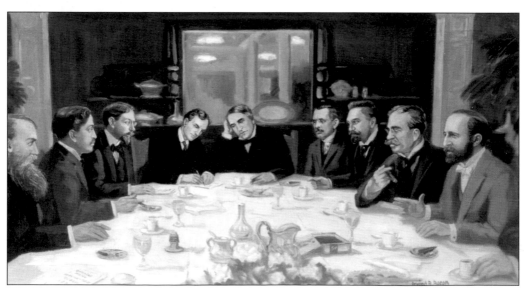

This oil painting by Irving R. Bacon entitled *Edison Illuminating Companies Convention Dinner* shows Thomas Edison (center) listening to Henry Ford sketch out his ideas on the gas powered engine. It was the first meeting of these two industrial giants in 1896. Samuel Insull is sitting to the right of Edison. (From the Collections of the Henry Ford.)

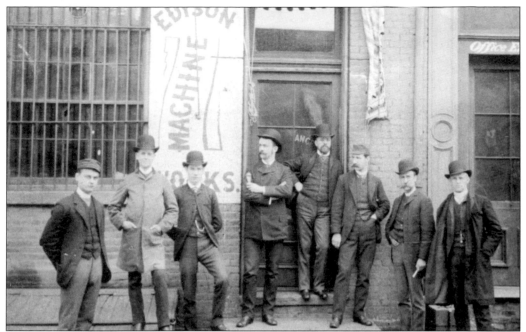

The Edison Machine Works in New York City was one of the many equipment manufacturing plants trying to keep up with new orders in 1885. In 1886, Edison consolidated much of the manufacturing in Schenectady, New York, and with the command to "Do it big, Sammy," he put Insull in charge of the operation. (Loyola University Chicago Archives: Samuel Insull Papers.)

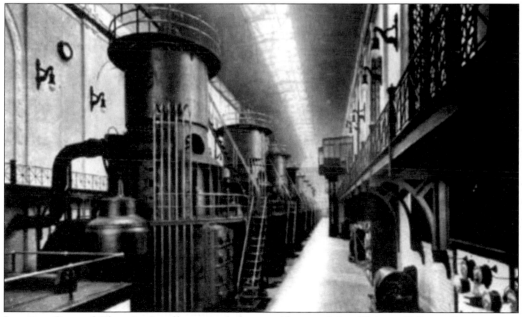

Leaving General Electric, Insull assumed the presidency of the Chicago Edison Company in 1892. He consolidated several smaller power companies to form Commonwealth Edison. He pioneered the use of turbine steam generators like those pictured above at the Fisk Street Station, and he began to form the wide area power grids in Chicago and the northern suburbs that would become standards for the industry.

Born Margaret Anna Bird to Irish immigrants, Gladys Insull was raised by her mother after her father disappeared seeking his fortune in the gold rush. To make ends meet, her mother ran a boardinghouse for actors. It was here that Gladys caught the acting bug. She took the stage name of Gladys Wallis and began a successful acting career with traveling theatrical companies. (Loyola University Chicago Archives: Samuel Insull Papers.)

Gladys Wallis was often the star of her acting company, and at the time of Samuel Insull's courtship, she was making as much as he. He had seen her several times walking on Michigan Avenue in Chicago and was quite smitten. Insull asked a friend to invite her to a dinner party he was to attend, and their meeting began a stage-door romance. (Loyola University Chicago Archives: Samuel Insull Papers.)

Because she was a member of a traveling troupe, the relationship of Wallis and Insull developed through almost daily letter writing. When some theatrical backstabbing put her out of work, Insull's support and sympathy cemented her affections for him, and they were married in 1899. (Loyola University Chicago Archives: Samuel Insull Papers.)

The Insulls' son and only child was born in 1900. The boy, named Samuel like his father and grandfather, was nicknamed "Chappie." Tending to business, Samuel was often away from home, leaving Gladys and her son alone on the farm together. When, in 1912, the boy caught scarlet fever, Gladys tirelessly nursed him for three months, further strengthening their bond. (Loyola University Chicago Archives: Samuel Insull Papers.)

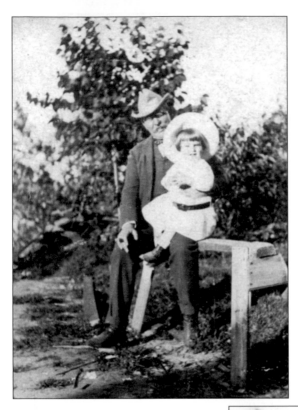

Samuel Insull, looking like Teddy Roosevelt, sits on a sawhorse with his son. Countering his wife's artistic aspirations for Sam Jr., Insull encouraged his mechanical aptitude. When his mother took him on a tour to see the landmarks of European culture, Samuel insisted that he also visit industrial leaders. Sam Jr. eventually went into the electrical business with his father and his uncle Martin Insull. (Loyola University Chicago Archives: Samuel Insull Papers.)

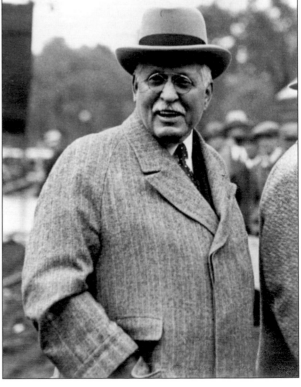

Besides his expanding electrical network, Samuel, at the zenith of his career, controlled People's Gas, was head of the Chicago Rapid Transit Authority, which ran the street cars and elevated trains, and he owned the major interurban electric lines. In short, he controlled the city's utilities and traction companies. He was the preeminent businessman in Chicago in the 1920s. (Loyola University Archives: Samuel Insull Papers.)

Samuel Insull financed the building of Chicago's Civic Opera House. Towering above the high tech stage and magnificent theater, the office space provided rentals to support the opera productions. The luxury penthouse at the top was Insull's apartment. Because the shape of the building resembled a chair when seen from the river, the building was known as Insull's throne. (Chicago History Museum, photograph by the Chicago Daily News.)

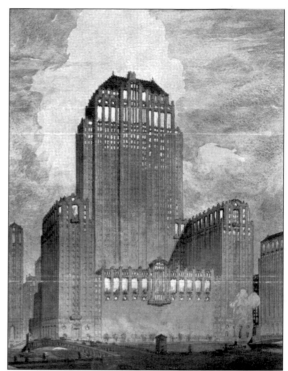

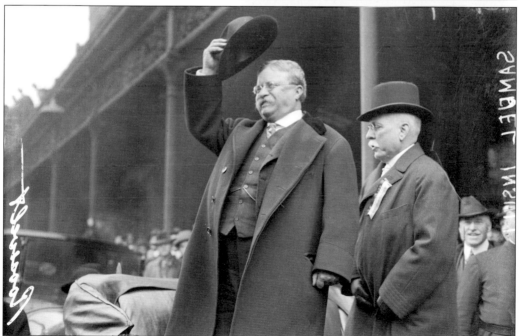

Insull's power and reputation were not confined to Chicagoland. Through his holding company, Middle West Utilities, his generating stations supplied power to 5,000 communities in 32 states. When the United States entered World War I, Insull was appointed head of the State Council of Defense of Illinois. Here Insull is pictured with former president Teddy Roosevelt in 1917. (Chicago History Museum, DN-0076539.)

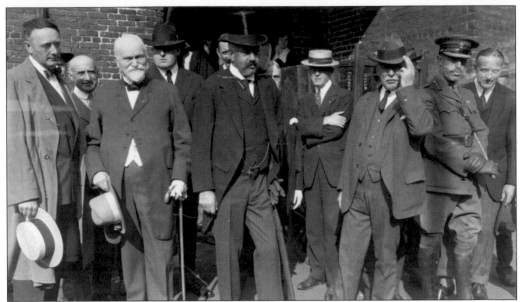

In these two photographs, Insull is pictured with three more notables. Above, Insull poses with fellow Englishman Victor Cavendish, the duke of Wellington and governor general of Canada (center), in 1918. Toward the end of his career, Insull was offered the job of supervising the construction of London's electrical grid. Given the troubles that eventually overtook his Chicago enterprise, he later regretted not having taken this opportunity. The photograph below, from 1927, shows Insull standing with Prince William of Sweden (center) and Julius Rosenwald, the chairman of Sears and Roebuck. During the first years of the Depression, Rosenwald covered stock margins for his employees and Insull followed suit for the workforce of Commonwealth Edison. (Above, Loyola University Chicago Archives: Samuel Insull Papers; below, Chicago History Museum, DN-0084130.)

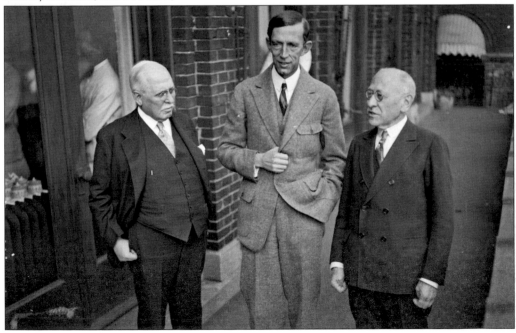

Insull also had an enduring impact on the area around his Libertyville farm. Elizabeth Condell financed the building of a 25-bed hospital in Libertyville in 1928. She challenged the community to become involved by requiring a public commitment of $5,000. Samuel Insull donated the land and money for the construction. Sam Insull Jr. donated $1,000 and was on the original hospital board. (Libertyville Historical Society.)

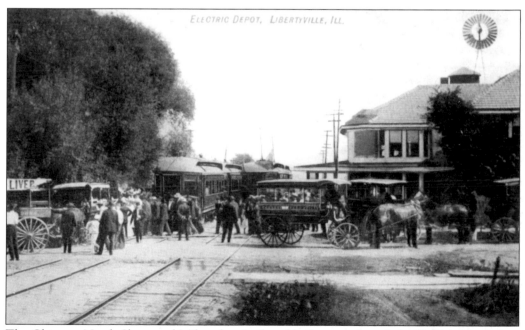

The Chicago, North Shore and Milwaukee Railroad built a spur from Lake Bluff to Mundelein through Libertyville (station pictured) in 1903. In 1916, Insull bought the bankrupt line and turned it into one of the country's fastest, most efficient interurban railroads. Under his leadership, the number of riders went from under one million to over seven million, and the line won several awards for best interurban in the country. (Libertyville Historical Society.)

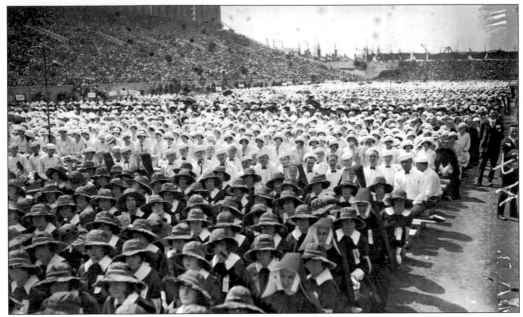

In 1926, at the suggestion of George Cardinal Mundelein, the Catholic Church held its Eucharistic Congress at Soldiers Field (pictured above) in Chicago with closing ceremonies at the St. Mary of the Lake Seminary in Mundelein. Samuel Insull moved back to his original farmhouse and gave his mansion to visiting members of the European clergy officiating at the congress. (Chicago History Museum, DN-0081776.)

On June 24, 1926, the closing day of the Eucharistic Congress, 200,000 people traveled from Chicago to the closing ceremonies at St. Mary of the Lake Seminary in Mundelein (pictured above) via Insull's North Shore railroad. Running every two minutes, 410 trains were used in what was an unprecedented logistical accomplishment for a commercial railroad. (Chicago History Museum, DN-0081726.)

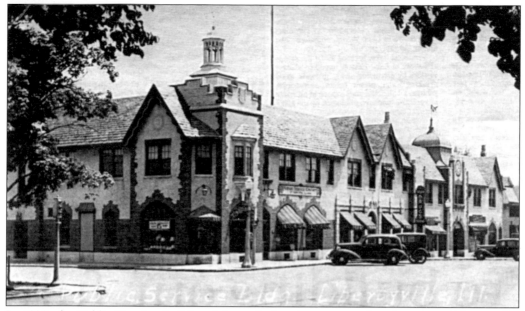

In 1928, the Public Service Building (pictured above) was opened in downtown Libertyville. Designed by Insull's architect Von Holst, it featured an arcade with a courtyard and lighted fountain in the rear. On the first floor was a bank and retail stores, including a model kitchen with the latest electrical appliances. On the second floor were 11 offices and 7 apartments. (Libertyville Historical Society.)

The various elements of Insull's empire complemented each other. The expanding power grid and commuter rail lines made it convenient for people to settle in the suburbs, which in turn created more demand for power and transportation. Insull took the next step and invested in new housing as well. The Highlands section of Libertyville and the upscale community of Countryside Lake (pictured above) were Insull projects.

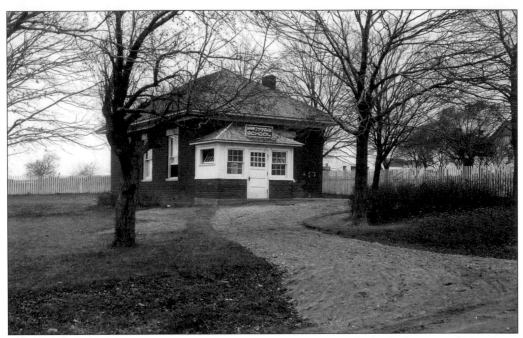

Samuel Insull employed as many as 60 people on his farm. In 1926, he built the original Hawthorn School for the children of his employees. It was a one-room schoolhouse, costing $18,000. It was on the west side of Milwaukee Avenue across from the present-day Red Top Plaza. Later Insull's butler lived in the building and Cuneo used it for employee housing as well.

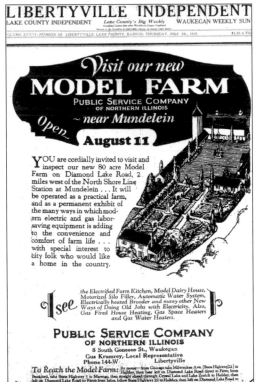

In 1928, Insull opened an 80-acre model farm in Mundelein. The farm was wired for electricity and piped for gas, and included barns as well as a typical farmhouse. In flyers, like the one pictured here, the public was invited to view what the latest gadgets could do for farming and for the home. Everything from washers and refrigerators to electric milking machines were on display. (Libertyville Historical Society.)

After decades of expansion, it must have seemed impossible that Insull's empire could crumble to dust, but the complex structure of holding companies that had helped to raise capital in good times were vulnerable to sustained recession. Cyrus Eaton (right), a Cleveland financier, was the nail in Insull's coffin. His takeover attempt forced Insull to borrow heavily using his personal property as collateral. (Loyola University Chicago Archives: Samuel Insull Papers.)

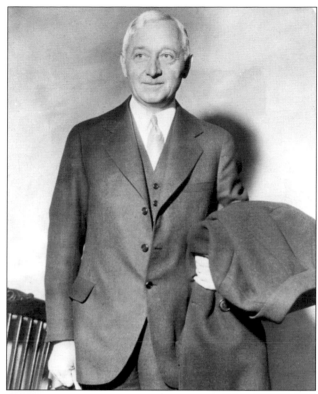

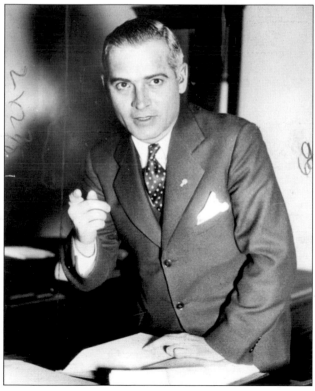

After resigning from his companies and relinquishing all his property to his creditors, Insull retired to Paris. When he was indicted on federal and state charges, he fled to Greece. After a year of legal wrangling, he was captured and returned to the states for trial. The Franklin Roosevelt administration put Dwight Green, who had successfully convicted Al Capone, in charge of Insull's prosecution. (Loyola University Chicago Archives: Samuel Insull Papers.)

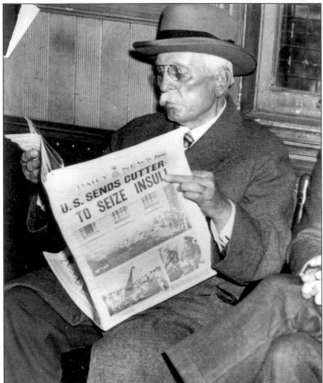

After being expelled by the Greeks, Samuel Insull was captured on a freighter in Istanbul's harbor. He was returned by ship under house arrest. After disembarking in New York, Insull is shown here reading about his own fate while waiting for the train to take him back to Chicago and to trial. (New York Daily News.)

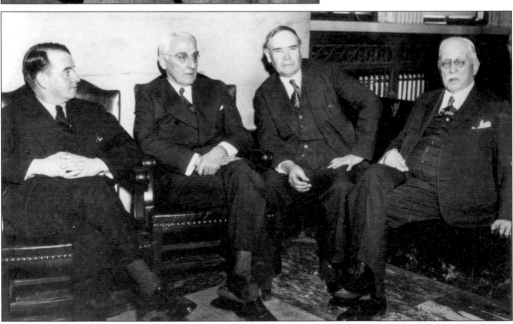

Here, from left to right, Samuel Insull Jr., Martin Insull, John Nothrup, and Samuel Insull await the verdict in the mail fraud trial. The government's case depended on complex bookkeeping evidence. When Samuel took the stand and told his life story, the courtroom was spellbound. The jury took two hours to reach the verdict of not guilty. (Chicago Tribune photograph by Paus and Steiger. All rights reserved. Used with permission.)

Gladys, Samuel, and Sam Jr. sit together after the trial. Although the Insull marriage suffered some rocky spells, the family stuck together during their trials. When she heard about Samuel's acquittal, Gladys said, "It is character that counts, not money." Sam Jr. said of his father, "the old gentleman gave me a ticket to a big race, and it was a lot of fun while it lasted." (Chicago History Museum.)

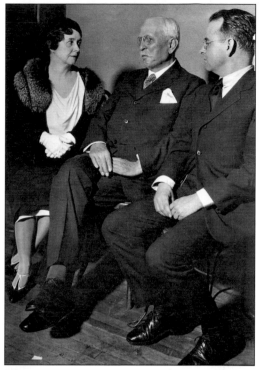

Samuel and his son rest on a trip to the Century of Progress International Exhibition world's fair in 1934. Samuel had arrived in Chicago in time for the World's Columbian Exposition in 1893. After having contributed so much to the technological evolution of the city in the "century of progress," it must have been a bitter experience to visit the new world's fair while awaiting trial. (Chicago History Museum.)

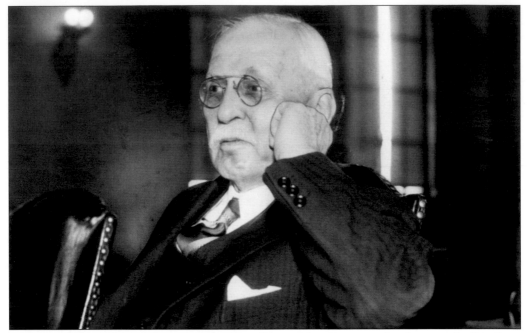

Fatigue and ill health are apparent in the face of Samuel Insull in court for the second of his three trials. He finally retired to Paris, where he died of a heart attack while crossing a subway platform. When found, he had 85¢ in his pocket. The story made headlines because it dramatized how far the great man had fallen. (Chicago Tribune photograph. All rights reserved. Used with permission.)

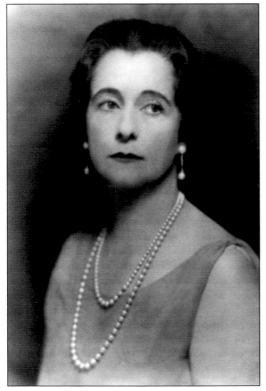

Gladys Insull was a woman of beauty and spunk. After her husband's death, she was bitter at the treatment he had received in his adopted country, and she refused to come back to the United States. She eventually relented and returned to be with her family in Chicago. She lived in an apartment at 1100 Lake Shore Drive, built by Benjamin Marshall. She died in 1953. (Loyola University Chicago Archives: Samuel Insull Papers.)

Three

THE HOUSES
THAT SAM BUILT

The photographs of the Barr farm and Samuel Insull's first home set side by side dramatically illustrate the transformation wrought by the gentlemen farmers on the residential style of the area. The small wood frame house surrounded by open field is replaced by what appears to be a larger house, but is simply enhanced by a wraparound sun porch, dormers and awnings, set on a sloped lawn and landscaped with shrubs and orchards. From simple, even stark, the house is transformed to elegant with a touch of luxury. And this was only a "starter home," with the mansion already in Insull's plans for the future. He mentions in one of his papers that he saw a house he admired in Italy. Like a kid in a candy store who says, "I want one of those," he had his architect conjure a Mediterranean palace on the Illinois prairie.

The firm of Marshall and Fox built the mansion for Insull with Benjamin Marshall getting primary credit for the design. There are thick books of blueprints in the attic of the mansion with everything from structural sketches to details of the flower motifs in the eaves and the color patterns in the marble floors. Even the type of hardware on the bread box in the kitchen is important enough to be the subject of correspondence among the contractors. Some of those letters are comical, as when Insull complains about too many papers blowing around the construction site from the wrappings of the workers' lunches. One of the builders grouses when Gladys Insull sent a fireplace from Europe for the library after the opening had already been cut to a different specification. The attention to detail was worth it, however, as a beautifully ornate home emerges in the following sequence of photographs.

Samuel Insull Jr. had his own homes in the area. When John Thompson's family sold the Red Top mansion to Samuel in the late 1920s, Sam Jr. lived there with his first wife. He also built himself a home on an island in his father's Countryside Lake development.

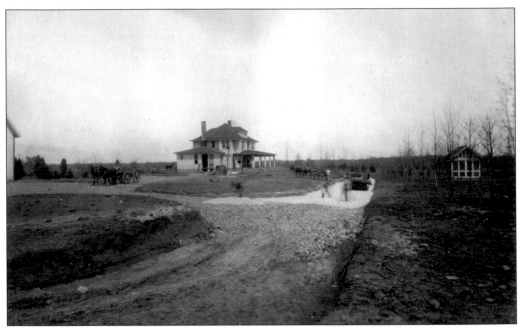

In 1907, Samuel Insull's first land purchase was the Barr farm. He probably already had a more spectacular mansion house in mind for the future, but his first residence was the remodeled Barr farmhouse. Photographs of the original house do not look very promising. Using horsepower, workers in the foreground are gravelling the driveway. In the second photograph, the addition of an extensive screen porch that wrapped around two sides of the house, and the addition of dormer windows with awnings transformed the original farmhouse into a respectable gentleman's country home. A large barn, which still stands on the property, a garage, and other outbuildings were also constructed at this time. These and the photographs on the next pages were given to John Cuneo Sr. by Samuel Insull Jr.

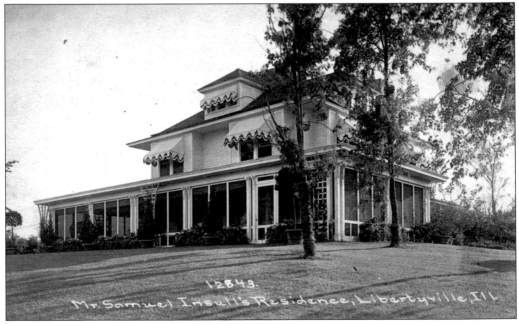

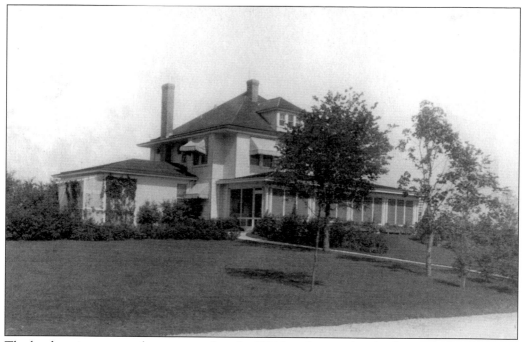

The landscaping was modest compared to the 1914 Jens Jensen plan for the grounds around the new mansion, but grading the front lawn to give the house a prominent perch and adding some tree and shrubbery plantings gave the remodeled house a pleasant setting, especially after a few years had brought the new greenery to maturity.

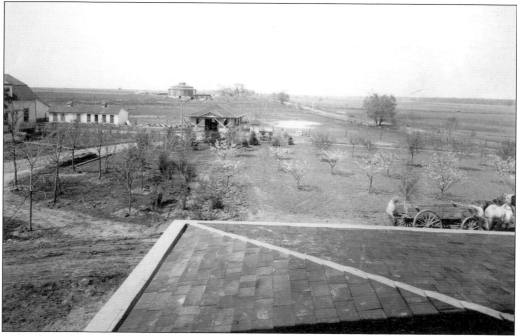

Looking north toward the village of Libertyville, the view from the roof of the remodeled house shows the extent of open land available. The expanse of grassland dwarfs the landscaping near the house. Milwaukee Avenue runs from the middle right of the photograph to the middle distance.

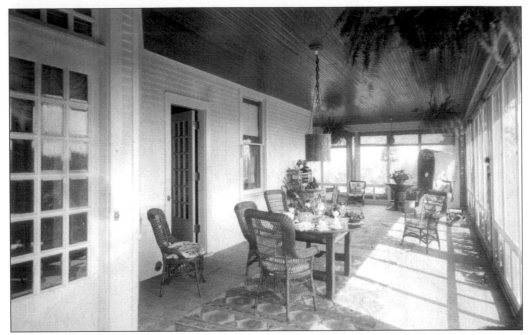

The long, wide porch was the most impressive feature of the remodeled house. With ferns and lamps hanging from the ceiling, carpet runners on the floor, and the usual cushioned wicker furniture, the porch had a rich, comfortable appearance. A lounger could adjust the curtains or move from one side of the house to the other to either take in or avoid the sun.

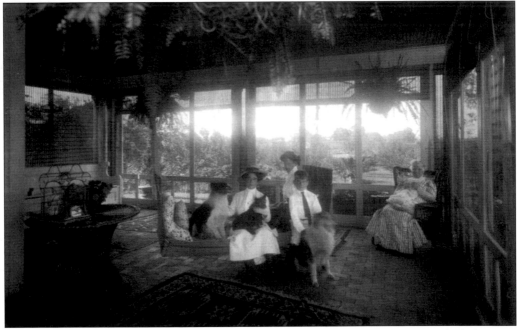

Here, Gladys Insull (center, seated) and Samuel Jr. to the right enjoy the porch swing. The lady sitting behind them is unidentified, but possibly Mrs. Benjamin Carpenter, a friend. The lady in the chair to the right who appears to be knitting is probably a family servant. With Samuel putting in long hours at the office, Gladys and Sam Jr. were often left to enjoy their country home together.

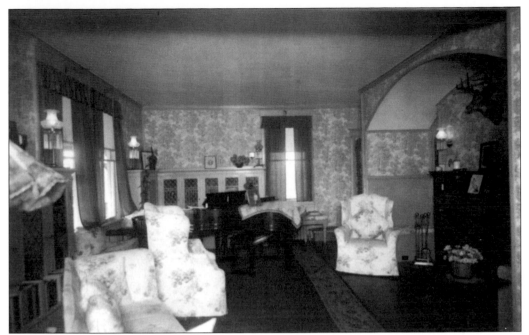

According to a contemporary newspaper account, during remodeling, the downstairs of the farmhouse was opened up by replacing walls with archways; one is visible to the right in the photograph above. The rooms were still relatively small, and the wallpaper patterns, the stuffed furniture, multiple lamps, and the piano create the crowded, rich look of a Victorian home.

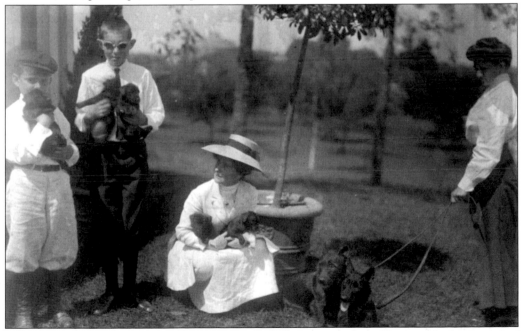

Gladys (center) is often pictured at her Libertyville home with dogs. Here, in the back yard of her home, she holds two puppies and looks to her son (left with hat) who clings to another of the litter. The boy in the sun goggles is unidentified as is the other woman, who again may be Mrs. Benjamin Carpenter.

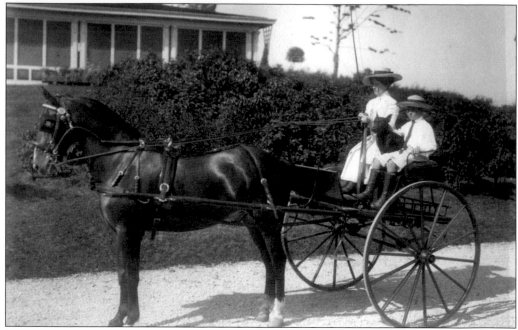

By all accounts, Gladys Insull did not like the country. She preferred the city with its access to her beloved performing arts. To divert her, Samuel Insull provided a surrey and a groom to drive her, but she often chose to drive herself. Years later, Sam Jr. built a home on one of the islands in Countryside Lake. Gladys would use the surrey to go back and forth between the properties.

Insull applied his characteristic drive for excellence to running his farm. In particular, he developed world-class breeds of Brown Swiss cows and Suffolk Punch horses. From his boyhood, Insull remembered the sound of the Suffolks' hooves as they pulled the milk wagons through the streets of London in the morning.

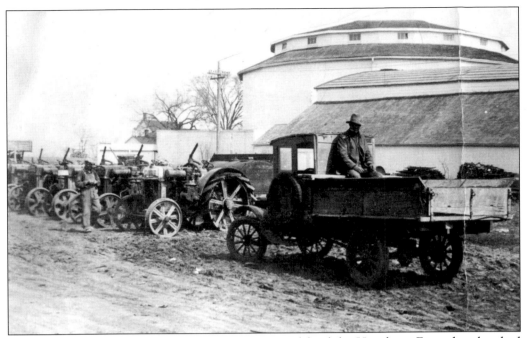

Insull was less successful with crops. As he acquired land for Hawthorn Farm, he absorbed 24 smaller farms. He tried to apply the economy of scale to farming and had 4,231 acres under cultivation in 1926. Despite employing the latest in agricultural theory and the most efficient business principles to the operation, to his surprise, Insull was still losing money on his crop.

Like his neighbors, Insull looked to his farm for relaxing activity. "Farming and the raising of livestock became quite a hobby with me, and I am sure the outdoor life which it necessitated is one of the reasons for my enjoying reasonably good health, notwithstanding the great pressure of business," said Insull in Larry Plachno's *The Memoirs of Samuel Insull*, from Transportation Trails, 1992, page 184. (Loyola University Chicago Archive: Samuel Insull Papers.)

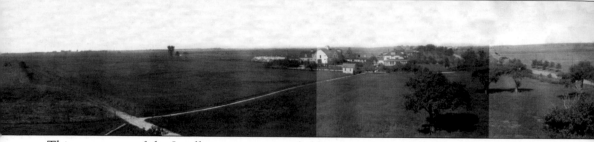

This panorama of the Insull property was probably taken about 1909. The photograph shows the remodeled Insull house, and the building cluster also includes a creamery, car garages, horse barns, storage sheds, and a large greenhouse. The big white barn still stands and is the oldest building on the Cuneo property. At various times, it has been used to keep the zoo animals during the winter months, to house both the family limousines and the chauffeur in the second

floor apartment, and, most recently, as the residence of the museum's executive director. The roadway in the photograph is Milwaukee Avenue. The tree line on the right indicates the Des Plaines River. The new mansion would be built in the area at the far left of the photograph in about five years.

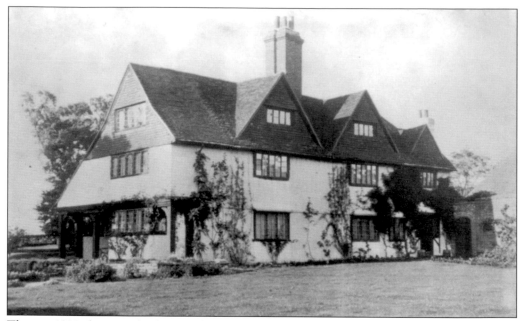

This is a 1932 photograph of an Insull home in England. It is unclear whether this is a home that Samuel Insull rented on one of his visits or whether he owned it. Given his English heritage, one might assume that Insull would have chosen this exploded Cotswold Cottage style or another Tudor Revival variation for the design of his dream house, but he had seen a house he admired in Italy.

In 1914, Insull chose prominent Chicago architect Benjamin Marshall to design a new home on his Libertyville property. Marshall was a talented, flamboyant man who had little formal training in architecture, but who admired the neoclassical style he had seen in the White City buildings of Chicago's world's fair. He designed the Iroquois Theater and the Drake, Blackstone, and Edgewater Beach Hotels in Chicago.

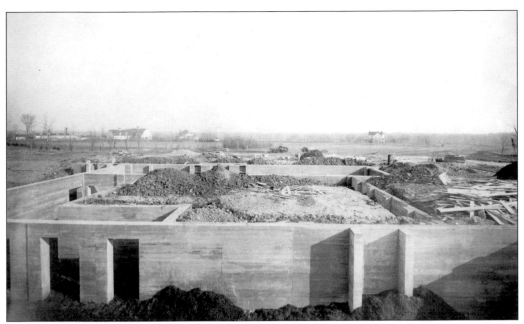

The mansion took more than two years to build. The Insulls remained in the farmhouse until their new home was completed. In this photograph, the builders have poured the foundation for the mansion. The farmhouse, with its cluster of buildings, is in the distant left center. During the Cuneo years, the farmhouse was subdivided and used for employee housing. It burned down in 1946.

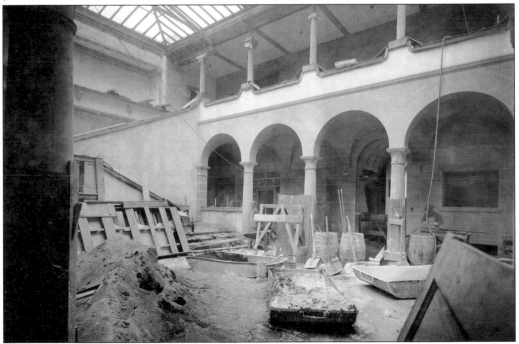

Cement mixing troughs and other equipment clutter the great hall during construction. In an Italian house, this arcaded hall would have been open to the warm Mediterranean sky. The climate in the American Midwest required a skylight, but originally it could be opened on fine days or warm evenings. Notice the blank rectangle below the balcony rail and the unfinished ceilings.

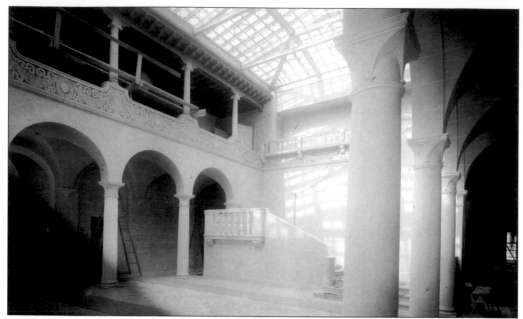

This photograph was taken a few weeks later and shows the great hall in a less cluttered state. Notice the blank area under the rail has been filled with an elaborate urn and vine etching. The balcony ceilings are now coffered—having alternate recesses and raised panels—with intricate painted patterns. An army of laborers, including Old World artisans, worked on the mansion. The hourly labor rate was about 70¢.

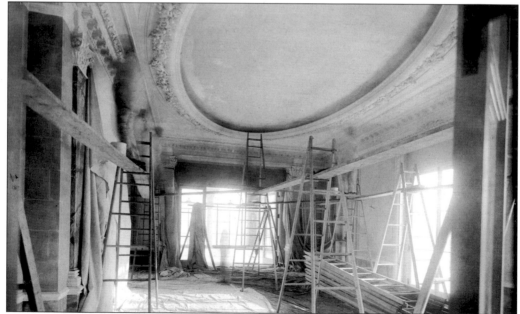

The formal dining room is not yet ready for guests. The most striking feature of the room is the oval design in the molded plaster ceiling. This disappeared before the Cuneo era. It is possible there had been some damage to the ceiling during the years between Samuel Insull's departure and John Cuneo Sr.'s arrival. There are two rooms in the mansion that still have a molded ceiling pattern.

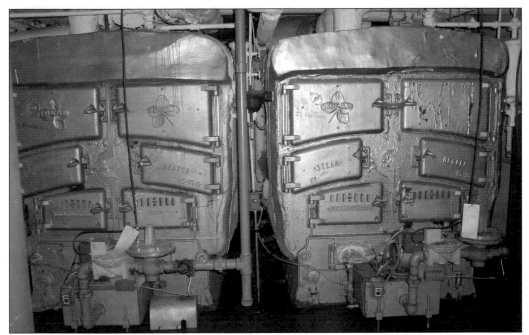

Samuel Insull knew and admired new technology. He had been a witness to Thomas Edison's many useful inventions. In marketing electricity, he stressed the use of labor saving devices like electric irons, stoves, and refrigerators. It is no surprise then, that in his own house he had the latest toys. These are the original boilers, which are still heating the mansion.

Many mansion houses of that era would have had a dumbwaiter to move heavier objects between floors, but Insull installed an electric elevator in his new home. The Otis Company actually numbers their machines and was able to confirm that it was installed in 1914. It is one of the oldest, if not the oldest, operating elevators in the county.

This ungainly looking machine is actually a clothes dryer, which Samuel Insull had installed in the mansion basement. Nothing like a tumble dry machine, the panels slide open and clothes are hung on a bar, pushed back into the metal chamber and baked dry.

Samuel Marshall designed a home office in the mansion. It is called the ship's room because the paneling on the wall came from the captain's quarters of an English sailing vessel. Each wall panel opens up to reveal storage space. Behind one of these, Insull had a phone booth installed, apparently to provide privacy for his business calls.

Vaulted ceilings, columns, and arches grace the main hall, the corridors, and several of the rooms on the ground level. The mansion is largely poured concrete with plaster finish and painted mortar lines creating the illusion of block construction. The pillars are Indiana limestone. The floor is travertine stone, quarried near Rome. Getting materials from Europe during the war slowed the construction process.

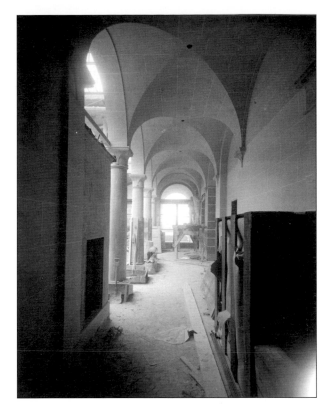

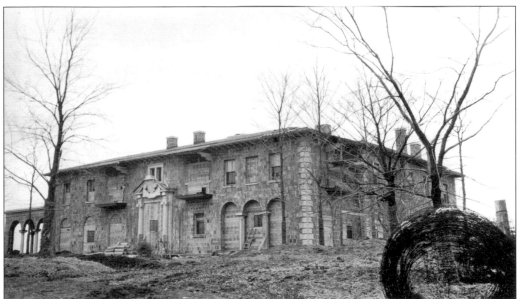

Jens Jensen, the landscape designer, must have been watching the mansion's construction with curiosity. He took a series of photographs of the process including this one of the almost completed mansion. Before the plaster finish was applied to the rough stone surface the mansion looked like the setting for a horror movie rather than a luxury residence. (Sterling Morton Library, the Morton Arboretum, Lisle, Illinois.)

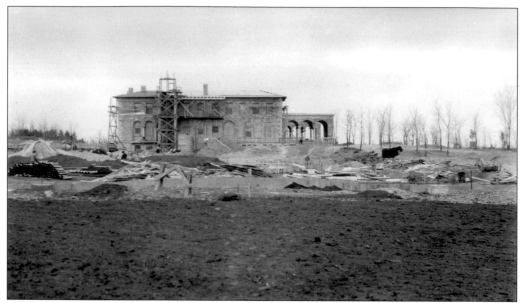

The landscape and construction crews worked simultaneously on their projects. One letter from a building construction foreman, lamenting the slow delivery of stone, complains that the landscapers will have his crew boxed in if they cannot pick up the pace. Notice the newly planted trees to the right of the still unfinished mansion. (Sterling Morton Library, the Morton Arboretum, Lisle, Illinois.)

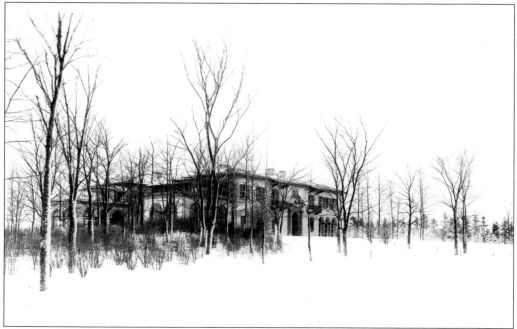

In late 1916, the mansion was ready for the Insull family. What was most noticeable at first glance was its color, a Mediterranean pink. Perched on the hills in Rome, bathed in amber sunlight, the color would have blended with its surroundings. Glimpsed through the bare trees of winter, offset by snow on the lawns, the pink jumped out of the background. To the locals, it became the pink mansion.

As the construction crews worked on the mansion, the grounds were transformed by Jens Jensen. Jensen was a Danish immigrant, who, while working for the Chicago Park District, built Columbus and redesigned Garfield and Humbolt Parks. His private clients included Henry Ford. He believed in using native plants, curving borders for beds and lawns, and water features, all of which he incorporated in the Insull estate. (Herbert Georg Studio.)

Jensen's job was to transform the flat, empty land into a blend of ideal natural settings—flower gardens, alternating lawns and woods, bird sanctuaries, ponds and streams and some trademark Jensen features such as council rings. Men and horses performed much of the labor, including laying networks of field drainage tiles.

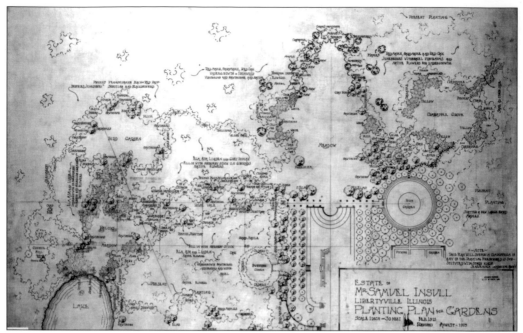

The signed garden blueprint from 1915 is Jens Jensen's design for the gardens at the rear of the mansion. A rectangular plot of perennials and vegetables and a sunken garden with roses around a central fountain were the main elements of the plan. Jensen disdained European-style formal gardens, but had to make concessions to his client's wishes.

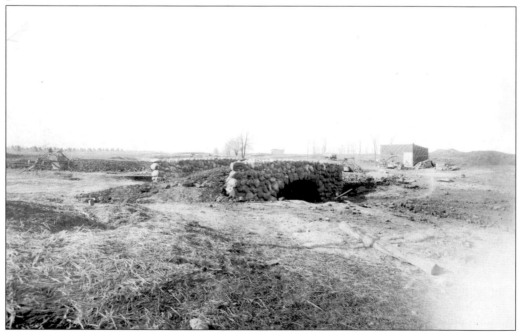

With no road to reach it and no water to cross this looks like a bridge to nowhere. Because of the emptiness of the land, the photographic record of the landscaping of the Insull estate often looks odd at certain preliminary stages. The gradual appearance of the beautiful forms of Jensen's design in the middle of what appears to be a wasteland is all the more impressive.

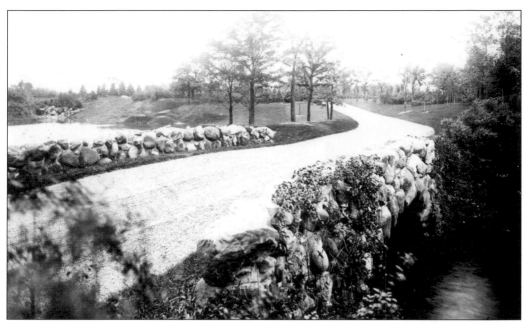

The completed bridge is crossed soon after entering the estate from Milwaukee Avenue, making the visitor aware he is entering a different environment. The fieldstone and mortar construction give the bridge a quaint natural appearance. Water features are common in Jensen landscapes. On the Insull estate he made three ponds fed by a shallow well pump over a waterfall and connected by short boulder-strewn streams.

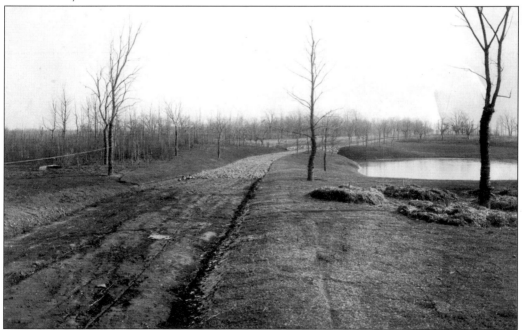

The long approach drive was common on the country estates. It gave the visitor time to appreciate the beauty and extent of the grounds and it controlled the first views of the mansion. The slight curve of the road and the border of trees also allowed the designer to vary and direct the view as one approached the house.

To keep them manageable, the original transplanted materials were necessarily small and immature. The selection and placement of plants only initiated the landscape plan. Jens Jensen had to imagine what the final result would look like after the trees and shrubs had matured. The photograph above shows the dramatic change in the appearance of the drive approach after the border trees have grown to full size.

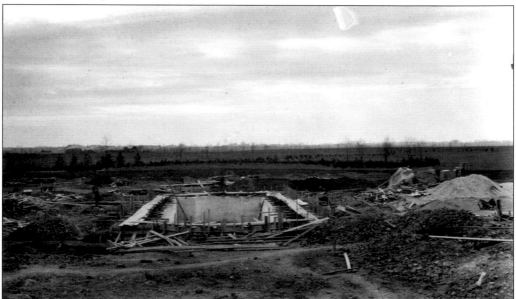

Privacy does not appear to be a problem for poolside parties at this swimming hole. The apparently empty fields stretching away to the horizon make this seem like an unlikely setting for a swimming pool. In this case the construction crews had the jump on the landscapers. (Sterling Morton Library, the Morton Arboretum, Lisle, Illinois.)

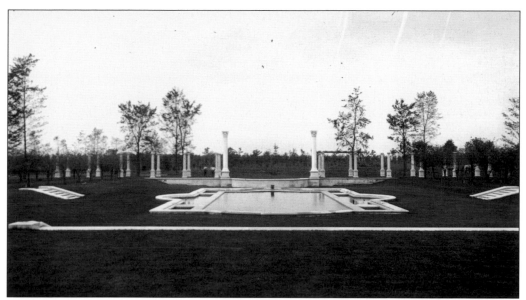

Over the years, the landscaping of the outdoor pool included an arbor vitae shrub, tiered rose gardens, and a cabana, but this photograph shows the original simplicity of design with a shallowly sloped lawn and short stairways. Notice the side pools which were to be lily ponds. (Sterling Morton Library, the Morton Arboretum, Lisle, Illinois.)

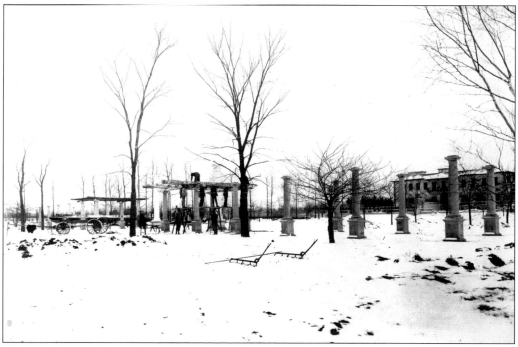

Workmen mount a pergola frame to the top of column rows. Eventually a vine covered the frame creating a leafy roof. At this time they also constructed grape arbors over the grassy walkways through the cut flower, vegetable, and perennial gardens. Both the pergola and the grape arbors disappeared some time during the Insull years or perhaps in the five years that the mansion was vacant.

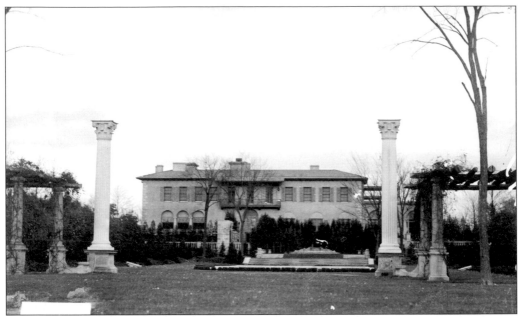

The completed colonnade created a perspective for the pool and mansion. The small grassy proscenium between the large columns was designed as a classical performance space for Gladys Insull to entertain dinner guests. Below the stage, the lawn behind the pool is sloped in an amphitheater style so that chairs could be set up for guests enjoying the performance. (Chicago History Museum.)

Jens Jensen disdained ornamental gardens, but his clients often wanted the European look of formal, shaped plantings. He reluctantly bowed to their wishes, as long as he could indulge his own vision in laying out most of the property. For Samuel Insull, he designed a vegetable and cut flower garden that has an organized look tempered by the wild abundance of perennials.

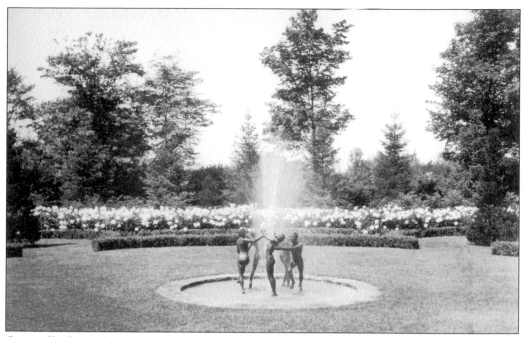

Originally the sunken garden featured this interesting fountain of dancing women in the center, which was replaced by spitting cupids some time later. The original plans designate rose bushes for the sunken garden. There were a series of these plant circles connected by grassy walkways in this section of Jensen's garden at the northwest corner of the mansion.

Unfortunately, there are few photographs of the Insulls in their newly constructed mansion. Here Gladys Insull, holding a dog, sits on the steps leading to the terrace in back of the house. A home this large and grounds so extensive could provide someone with a solitary bent a grand place to thoughtfully meander. A more social personality might see the spaciousness as merely empty. (Loyola University Chicago Archives: Samuel Insull Papers.)

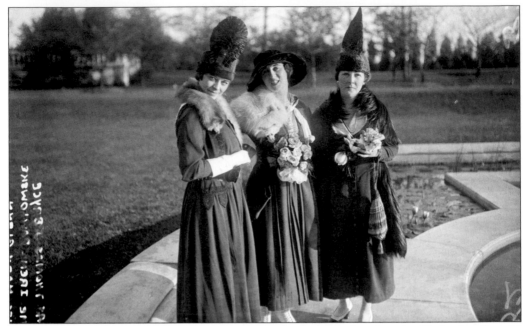

Although Samuel Insull's contacts were extensive, he had few close friends. Gladys Insull could have played a larger role in Chicago's social world, but she found the wives of the city's elite frivolous. However, one can assume they did occasionally entertain guests at their new home. Here some ladies in interesting hats pose poolside—Irene Pawlowske, Mrs. Thomas Bryce, and Mary Glenn. (Chicago History Museum, DN-0068916.)

Insull was appointed chairman of the Illinois State Defense Committee in 1917. He took the job very seriously and applied his business skills to raising funds for the war effort. The event pictured in this sequence of three photographs may have been part of his effort as head of the defense committee. Pictured are Ensign and Mrs. Thomas Bryce. (Chicago History Museum, DN-0068917.)

These photographs were taken in 1917, just after the mansion was completed. The building and landscaping have a clean, newly minted look to them. Here some guests stand by the swimming pool. Notice the lily ponds on the sides of the main swimming pool. Pictured are Captain Brooke, Mrs. Lawrence Viles, and Majors Keown and Wright. (Chicago History Museum, DN-0068924.)

There were two more Insull homes in the area. Samuel Insull Sr. purchased the John Thompson mansion, and Samuel Insull Jr. lived in the home. In 1927, Sam Jr. sent this Christmas card, which features a winter image of the mansion. According to one account, the house was not properly deeded to young Insull, and when his father's property went into receivership, the Red Top mansion was confiscated. (Libertyville Historical Society.)

BEST WISHES FOR CHRISTMAS

AND THE NEW YEAR

1929 FROM 1930

MR. AND MRS. SAMUEL INSULL, JR.

1244 STONE STREET

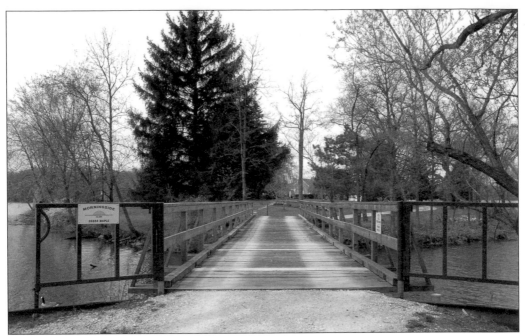

In the years before the fall, Samuel Insull Jr. prospered in his role as manager in his father's sprawling corporate structure. When his father developed the Countryside Lake residential district, Sam Jr. had a home built on an island in the lake for $50,000. The home is privately owned today and is just visible on the other side of the bridge in the photograph above.

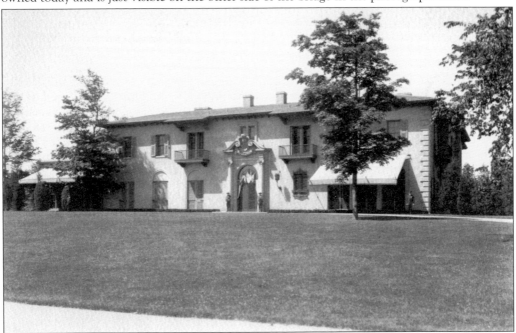

Samuel Insull lost his mansion and the 4,300 acres of farmland he had accumulated to his creditors in 1932. He summed up the experience in Larry Plachno's *The Memoirs of Samuel Insull*: "One of the great regrets of my financial troubles was the fact that this estate had to pass into the hands of my creditors."

Four

FROM PRODUCE
TO PRINTING

Although Giovanni and Caterina Cuneo, John Cuneo Sr.'s grandparents, were born in Liguria, the Cuneo family originated in the town of Cuneo in the Piedmont Region of northern Italy. Like many European immigrants of the 19th century, Giovanni and his brother were captivated by stories of gold strikes in the American west. They left Genoa and came to America in 1857, and while his brother continued to San Francisco, Giovanni settled in Chicago with his family. He ran a farm and a grocery store and invested in real estate, establishing what was to become a successful business trend for the family.

Giovanni's son, Frank Cuneo, started the wholesale produce and nut firm of Garibaldi and Cuneo in 1882 on Chicago's South Water Street Markets. Like his father, he invested in real estate and developed the Wilson Avenue business district. He was one of the founders and the first president of the Italian Chamber of Commerce in Chicago. He was one of the principle organizers of the World's Columbian Exposition in 1893. He helped the Italian nun and first American saint, Mother Cabrini, to establish Columbus Hospital in Chicago and later opened the Frank Cuneo Memorial Hospital in memory of his wife, who had died in 1891.

John Cuneo Sr. carried on the family tradition but in a new field—printing. Besides founding the Cuneo Press, he also developed commercial real estate, most notably the Golf Mill Shopping Mall in Niles. His influence on the area around his country residence was far-reaching, particularly in his Hawthorn Mellody farming operation and in the sale of land for the Hawthorn Mall and Gregg's Landing. He was a devout Catholic and he supported both St. Joseph's Church in Libertyville and the St. Mary of the Lake Seminary in Mundelein. Finally, he left a quiet oasis in the rapidly growing area by saving his home and estate as the Cuneo Museum and Gardens.

Although his brothers were born in Italy, Frank Cuneo was born in Chicago. The Cuneo family was well established and fully engaged in the life of the city, particularly in the Italian American community, by the time John (pictured above) was born in 1884. John was restless and a bit unruly as a youth, but when opportunity presented itself, he was able to channel his energy into building successful enterprises. Like Samuel Insull, he was bold and supremely confident in his managerial abilities. Throughout his career he took over and turned around failing businesses like *Liberty Magazine* and the National Tea food store chain. Again like Insull, he believed in technical innovation and he invested in modernizing his plants, whether printing or milking. A pioneer in advertising, Cuneo was one of the first to use celebrity endorsements to sell his milk products. He pursued his hobbies with characteristic energy and passion. He was an avid collector, and the mansion is full of treasures he acquired from around the world.

John Cuneo Sr.'s grandfather and great-uncle came to this country seeking opportunity. Cuneo's great-uncle continued to California, and the fortune he made in San Francisco helped his son in law, A. P. Giannini establish the Bank of America. Cuneo's grandfather Giovanni (pictured with his family) stayed in Chicago and established a farm and grocery business, and, in what became a family trend, invested in property.

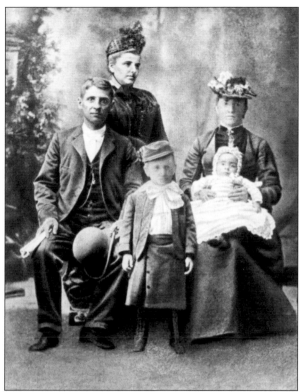

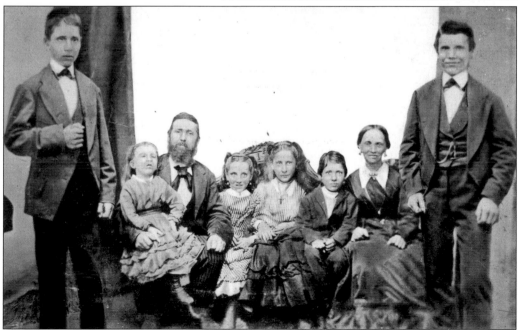

Giovanni Battista Cuneo, his wife Caterina Lagomazini Cuneo, and their children sit for a formal portrait. The couple was married in Italy in 1851. They emigrated from Genoa in 1857. The family probably originated in the town of Cuneo near the French border. His two elder brothers were born in Italy, but Frank, John's father, was born in Chicago in 1862.

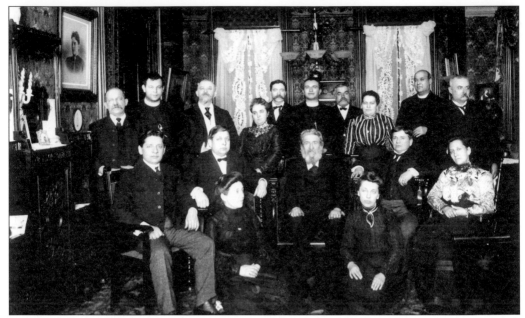

Giovanni Cuneo built a home for his family at Monroe and Wells Streets in Chicago. Frank Cuneo Sr. remembered that from the house, he could see Lake Michigan. That house burned in the Chicago Fire in 1871. Frank and his father waded to safety in the lake. Here Giovanni is in the center of his family and friends with Frank seated front left. Caterina Cuneo is absent, probably deceased, dating this photograph at about 1900.

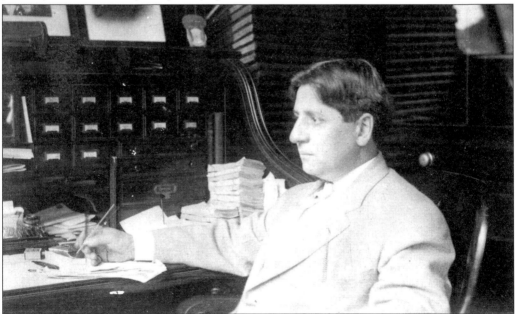

Frank started Garibaldi and Cuneo, a wholesale produce and nut vendor in 1881. He also organized Chicago's Merchants' Fruit Auction in 1888, and he helped to establish the United Fruit Company. He was a director of the World's Columbian Exposition of 1893. He moved his own house at Sheridan Road and Wilson Avenue six blocks to 4849 Sheridan Road, so that he could start the development of the Wilson Avenue business district.

Garibaldi and Cuneo was originally located at State and South Water Streets in the old Chicago produce market. In 1925, the market was relocated to the west side and Garibaldi and Cuneo moved with it to Fifteenth Street and Racine Avenue. It remained the cornerstone business of the Cuneo family during Frank Cuneo's lifetime.

Your Christmas Book is bound in the time honored way of the early bookmakers. The foredge has not been trimmed in order to preserve the original beauty of deckle edge paper used in this book. As a result, some pages are uncut. They may be carefully cut with an ordinary letter opener, as it was done during earlier days.

PUBLISHER'S PREFACE

THIS is the thirty-fifth opportunity we've had to prepare this gift for you. To those of you who received the first volume during World War II, to those of you who joined us along the way, and to those of you for whom this is the first volume, I wish the happiest of Holiday Seasons and the finest of New Years.

Christmas, 1976

Chairman of the Board
THE CUNEO PRESS, INC.

Frank Cuneo sent his son John to Yale University to prepare him for the family business. John was impatient and left school early. His father told him to find his own job, which he did in a bookbindery. He learned his new trade carefully and borrowed $10,000 from his father to buy his own bindery, which became the Cuneo Press. Part of what he learned he used in printing the annual Christmas employee book.

75

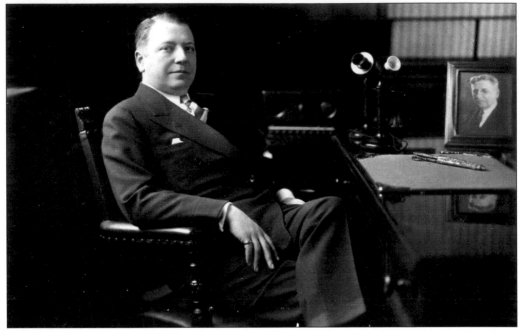

Sitting at his desk, a young John Cuneo Sr. is relaxed, well groomed, confident and ready to do business. The photograph on the desk is his father, Frank. The blotter pad, letter opener, two telephones and intercom were the tools of the trade then. These would be replaced by the computer and monitor today.

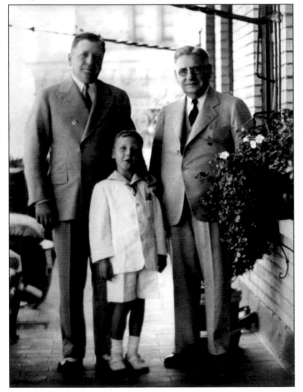

Frank, John Sr., and John Jr. pose for a formal portrait. Frank, who owned prime real estate in Chicago, advised John Sr. to buy land in Libertyville when the Insull farm went up for sale. He eventually amassed over 2,000 acres before selling parcels for development. John Jr. purchased a home near Grayslake and, after years of acquiring adjoining land, has a large farm of his own.

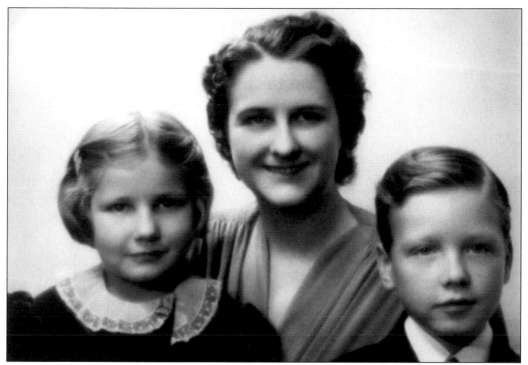

In 1930, John Cuneo Sr. married Julia Shepherd. Julia also came from a wealthy family. Her grandfather founded a railroad supply company in Chicago. They had two children, John Jr. and Consuela. The Libertyville mansion was their primary residence, but they maintained a luxury apartment at 1500 North Lake Shore Drive.

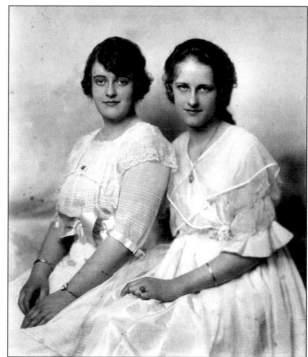

Josephine (left) and Julia Shepherd are pictured here in a formal portrait. Josephine never married and lived most of the time with her sister's family in the mansion. The sisters were inseparable companions and called each other by their childhood nicknames of Dodo and Tado.

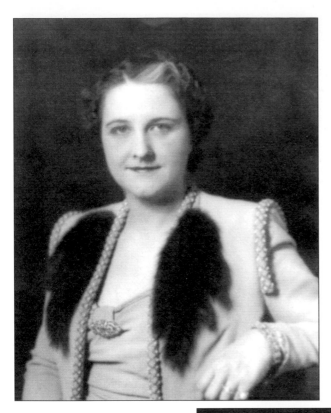

Julia Cuneo was known as a hostess of warmth and wit. She successfully organized a large annual fund-raiser for the Frank Cuneo Hospital for many years. She was a woman of some grit. When the Cuneos were robbed at gunpoint in the city, she refused the bandit's demand for her wedding band until her husband talked her into relinquishing the ring for safety's sake.

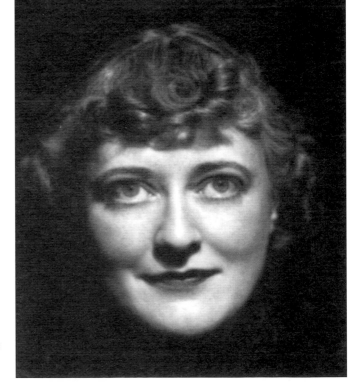

This striking photograph of Josephine Shepherd looks like a publicity shot for a movie star. Shepherd was a naturally warm, friendly, and unpretentious personality. She was often seen driving with her sister Julia and always offered a wave and a smile to people she passed.

John Jr. and Consuela Cuneo are seen with their dogs on the front step of the mansion. Living on a country estate provided many opportunities for play and amusement. A small, one-room house close to the mansion was known as the playhouse. John Sr. built a large horse arena for his prize hackneys and Consuela became an accomplished horsewoman. John Jr. was fascinated by animals and eventually ran the Hawthorn Mellody Zoo.

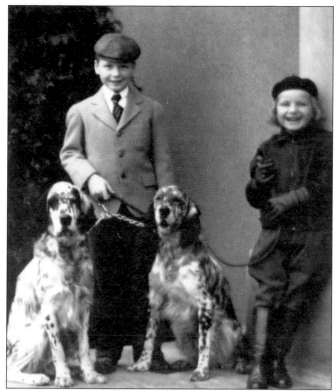

Like Samuel Insull, John Cuneo Sr. pursued his hobbies with the same passion as his profession. He raised a herd of championship Hackney ponies, which he showed around the country with great success. In 1940, he built a horse arena near the mansion. Stables for the prize herd surrounded a large oval riding arena. The arena burned in 1976, and many of the horses were lost in the fire.

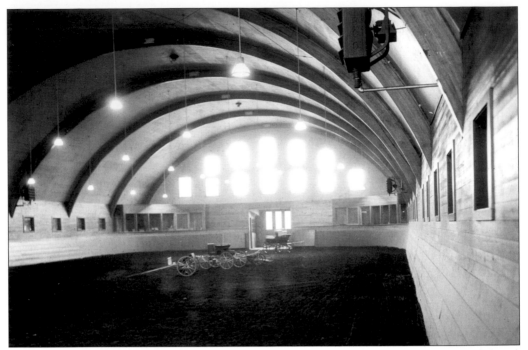

The horse arena was a large shell of a building with spacious tanbark riding oval (pictured above) in the middle for exercising the horses or for riding on rainy days. There were display rooms in each corner with large picture windows that looked out onto the arena.

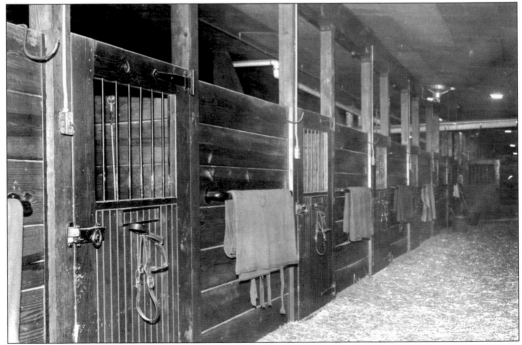

The horses were stabled in stalls around the perimeter of the building with a circular walk running between the stall doors and outer wall. There was room in the back for John Cuneo Sr.'s growing carriage collection that was eventually displayed in a separate building.

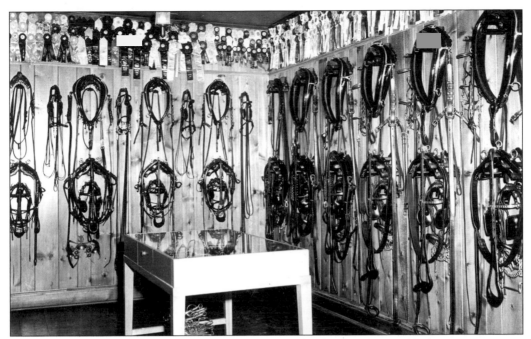

The tack room in the horse arena also served as a trophy display. Cuneo's Hackney ponies went to shows all over the country and they often brought back the ribbons that are seen here on the walls. One particular horse, Wensleydale Pilot, won the Rochester harness show three times, thus earning the Warham Whitney Memorial Trophy, which is in the museum's silver collection.

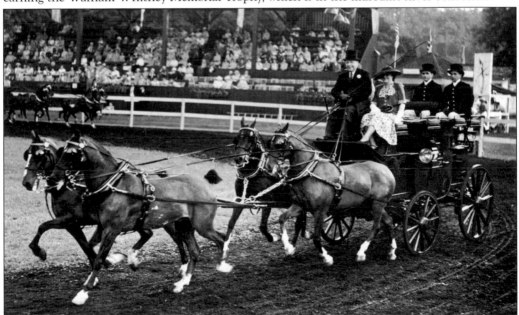

On any given weekend, Cuneo could be seen perched high on a carriage seat, driving a team of horses somewhere on the bridle paths and roads that circled his acres of farm fields. In the winter the groundskeepers were instructed to leave a few inches of snow on the roadways so the horse drawn sleighs would glide easily. In this photograph he drives a team at a show with Julia at his side.

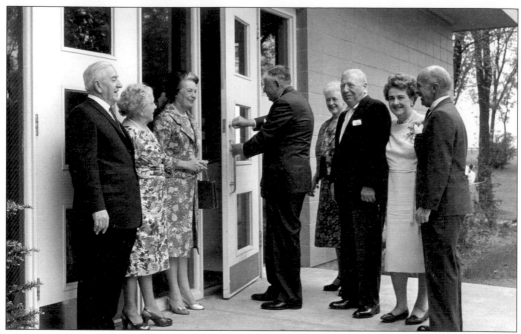

Another of John Cuneo Sr.'s hobbies was collecting antique carriages of all kinds from all parts of the world. He acquired so many he needed a separate building to house them all. The photograph above captures the ceremonial opening of the new Carriage Museum in 1964. Cuneo is third from the right with Julia Cuneo to his right and Josephine Shepherd behind him.

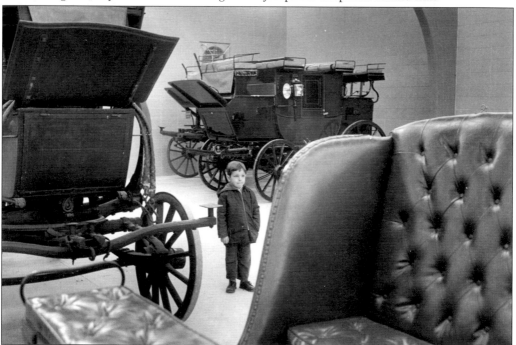

Cuneo's carriage collection included a Wells Fargo stagecoach, horse drawn hearses, Russian sleighs, and an English Hansom cab like the ones hailed by Sherlock Holmes. In the photograph, a young boy takes in the sights. The public was welcome to visit.

John Cuneo Sr., like Samuel Insull, was successful in a number of businesses, but his flagship enterprise was the Cuneo Press. The Cuneo Press was at one time the largest printing operation in the United States. The headquarter plant (in the photograph of the model above) was located in Chicago near Comisky Park, but Cuneo had presses in four other cities as well.

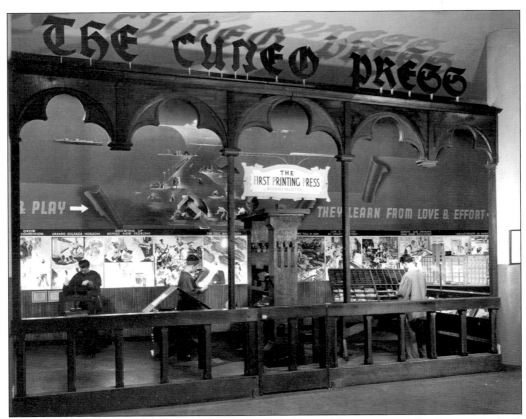

Whether it was the dairy or the press, Cuneo prided himself on equipping his businesses with cutting edge technology, and he used the idea of innovation to market his products. The Cuneo Press exhibit at the Century of Progress International Exhibition, the 1933 world's fair in Chicago, featured costumed reenactors demonstrating advances in printing over the centuries.

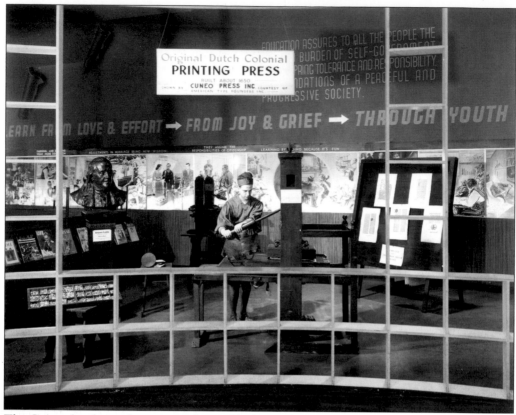

The Cuneo family involvement in the world's fairs indicates both their vision of the importance of innovation and the role the fairs played in promotion of business and the city. Frank Cuneo was a member of the board of the World's Columbian Exposition in 1893. Besides providing the press exhibit for the Century of Progress International Exhibition, the Cuneo Press printed much of the official fair literature.

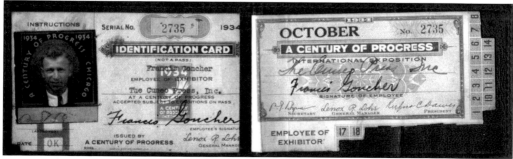

The exhibits at the world's fair required continual maintenance and in the Cuneo Press display, there were actors manning the vintage printing machines. With the extensive fair campus and huge number of visitors, security would have been an issue. Employees were issued identification cards and passes like the one pictured above. (Frank Goncher Jr.)

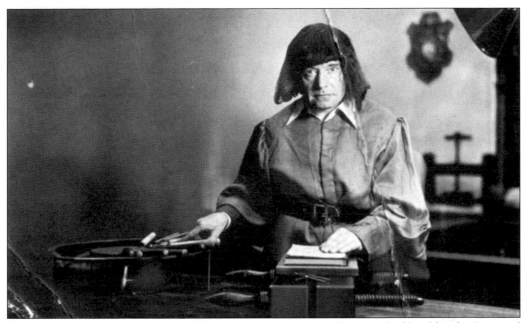

The gentleman in the somewhat disheveled costume is the distinguished bookbinder Leonard Mounteney. Formerly of Riviere and Sons in London, he worked at the Century of Progress International Exhibition exhibit for the Cuneo Press and offered to consult with "clients interested in bindings of quality and distinction for the library or as gifts." (Frank Goncher Jr.)

One of the milestones in the success of the Cuneo Press was a contract to publish the major Hearst magazines like *Cosmopolitan* and *Redbook*. William Randolph Hearst was a major force in publishing in the early 20th century. John Cuneo Sr. convinced Hearst that centralizing the printing of his magazines in Chicago would save on postage. On this photograph's inscription, Hearst wishes Cuneo well and invites him for a visit.

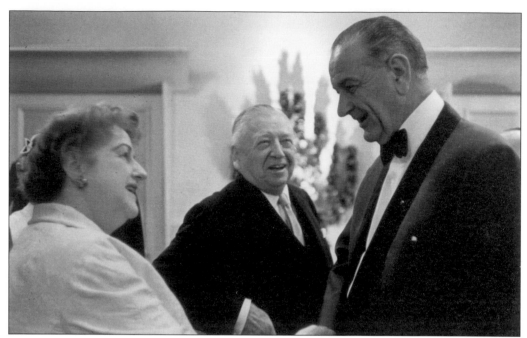

Like Samuel Insull, John Cuneo Sr. came in contact with the rich and powerful, and William Randolph Hearst was only one of many. In these two photographs, Cuneo seems to be covering his political bets by meeting both the Democratic president Lyndon Johnson and the Republican president Richard Nixon. These photo ops were, of course, brief arranged events. In local politics, the connections were more personal. Cuneo was friends with Mayor Martin H. Kennelly, who shows up in photographs of important events at the Libertyville farm, like the opening of the dairy in 1949. Cuneo was also acquainted with Mayor Richard J. Daley and with all of the archbishops of the Chicago diocese. He had a particularly close relationship with Cardinal Strich.

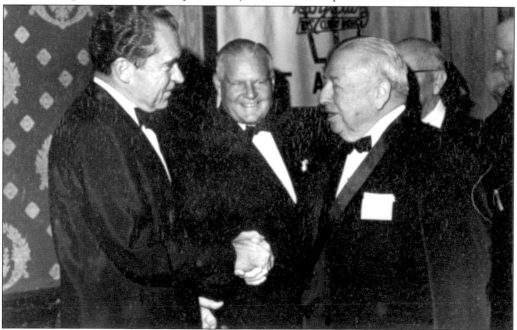

In 1944, John Cuneo Sr. acquired controlling interest in the National Tea food store chain. When his dairy became a big success, he was able to use the food chain as an outlet for its products. Cuneo built the mall in Libertyville at the corner of Milwaukee Avenue and Route 176 that included the local National Tea grocery store pictured above.

Cuneo loved horses and show competition. He became chairman of the Chicago Horse Show, which was part of the International Live Stock Exposition held annually at Chicago's International Amphitheater. Cuneo had a box on the main floor arena to watch Hawthorn Mellody's show entrants perform. Pictured at right is the cover from the 1950 show program.

Proj: Mill-Run Playhouse
 Niles, Illinois
Arch: Belli & Belli
G.C: A. W. Heinson & Co.
Date: 4/8/65

In 1965, John Cuneo Sr. built the Golf Mill Shopping Mall. It was one of the first major malls in the area and included a cinema and a theater in the round. The Cuneo companies have offices in the Golf Mill Bank building. John Cuneo Jr. still owns the property and had the mall enclosed some years back.

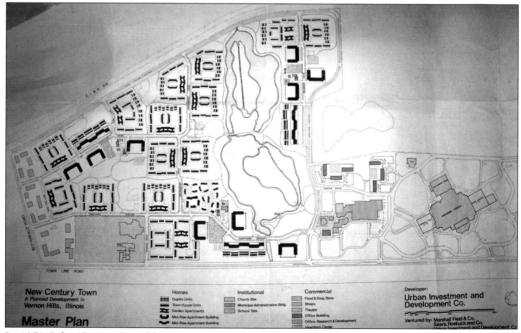

In 1971, John Cuneo Sr. sold 590 acres of land to Urban Development. Since the Cuneo land had always been part of Libertyville township, John originally had approached that village with the development plan, but when the town leaders balked at the expansion, he reached agreement with Vernon Hills.

88

Frank Cuneo knew and admired Mother Cabrini, the Italian nun and first American saint, who founded Missionary Sisters of the Sacred Heart. He gave her order a hospital at 750 West Montrose, which was named appropriately the Frank Cuneo Memorial Hospital. The image above is from a program to dedicate a new addition in 1959.

Samuel Insull built the first Hawthorn School for the children who lived on his farm. The one-room schoolhouse was on Milwaukee Avenue. A new Hawthorn School was later built on Route 60. John Cuneo Sr. granted the land easement for the new school. This building was surrounded by new additions, but it survived until the Townline School was built a few years ago.

The Cuneos were parishioners of St. Joseph Church in Libertyville. When the new church building was erected, Julia Cuneo donated the altar stone, the organ, and a beautiful painting of the Madonna and child, which now hangs on the left side of the altar. The greenhouse on the Cuneo estate supplied holiday flowers for the church each year.

In 1950, to recognize his many services to the Catholic Church, John Cuneo Sr. was invested with the Grand Cross of the Order of St. Sylvester, the highest honor a member of the laity can receive from the church. Here he is pictured on the day of his appointment ceremony with Cardinal Mondini, who would later become Pope Paul VI.

Five

KIDS, ANIMALS, AND CELEBRITIES

For many Chicago-area residents, the name of Hawthorn Mellody still evokes memories of the dairy and amusement park that attracted thousands of visitors to Libertyville every summer for almost 20 years. The farm park evolved in the early 1950s and was the creation of John Cuneo Sr.'s promotional genius.

Cuneo started the dairy in 1937 when he took over the property. In 1945, he gained control of the National Tea food store chain, which provided a distribution network for his dairy products. By the late 1940s, the Hawthorn Mellody Dairy had a fleet of trucks garaged in Highland Park to deliver milk along the north shore as far as Evanston. Cuneo decided to build a new facility that incorporated the latest in sanitary handling of the milk. The new building included a viewing gallery for visitors to watch the cows being milked with the latest hygienic equipment. The milking parlor proved to be a great attraction, drawing hundreds of families from the city on the weekends. Cuneo saw an opportunity to expand the attraction and increase the promotional possibilities.

In the summer of 1951, the Children's Zoo opened. Built before habitat replication became the standard, the zoo was a modest oval of cyclone fencing, but it housed a respectable selection of animals from around the world. In 1952, the Club of Champs opened. Photographs of athletes and sports memorabilia were on display. Eventually the trophies were moved to a separate room, and the front of the building became the Country Store. In 1955, television star Hopalong Cassidy drew almost 20,000 fans to the opening of the H-M Bar 20 Ranch and Frontier Town. Hawthorn Gulch, as it was later called, consisted of storefronts modeled after the frontier towns of western movies. Later the whole village was moved one mile north to provide a destination for a miniature steam train. This variety of attractions now provided a full day's entertainment for visitors and during its peak years, the farm park drew several hundred thousand guests in the course of a summer season.

In 1937, when John Cuneo Sr. took possession of the core of what had been the Insull estate, he started a full range of farming activities on the property. He raised chickens, turkeys, pigs, and dairy cows. He established his farm as he did his other businesses, investing in the latest equipment and facilities and hiring expert managers. Above, a champion bull poses for the camera.

The old poultry buildings like the one pictured above were simple chicken houses with open floor space and trough feeders. Later John Cuneo Sr. built a totally mechanized poultry operation along Butterfield Road with hundreds of thousands of chickens. Like the dairy earlier, it was a model of modern agricultural technology. As nearby property was developed, new residents often expressed concern about the pungent aroma.

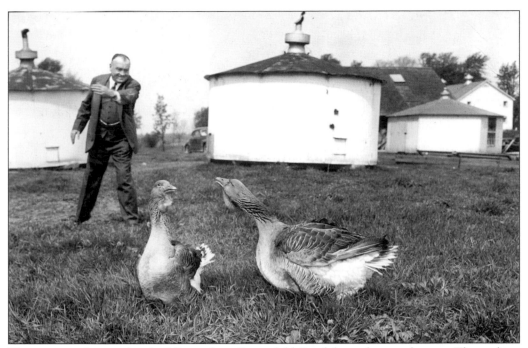

There were other poultry buildings along Butterfield Road for turkeys and geese. The turkeys were butchered and given to farm employees for the holidays. In this photograph, an unidentified man, who looks remarkably like J. Edgar Hoover, challenges two ill-tempered geese.

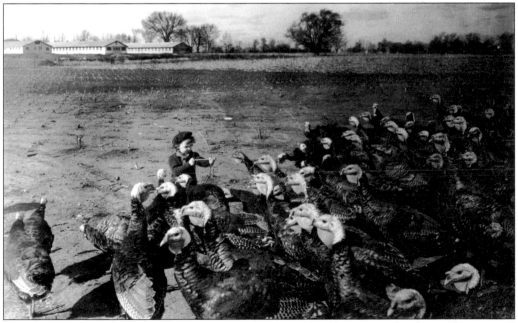

In the photograph above, little Carla Snyder bravely holds off an army of turkeys. The original buildings of the Hawthorn poultry farm are visible in the background along Butterfield Road. Snyder was the daughter of the farm's publicist and was often recruited as a model for photographs. She admitted that she was often afraid of the animals she posed with, but that is not apparent here. (Carla Belniak.)

The Hawthorn Mellody hog farm, like the poultry farm was along the east side of Butterfield Road, a little further north. In this photograph, two workers guide the pigs back to their barn. The hog operation never grew into a major business like the poultry and dairy operations, but new barns were built and the hogs were residents until the farm began to close in the late 1980s.

The many farming operations that John Cuneo Sr. started on Hawthorn Mellody required a large number of workers. In the early years, many of the laborers came from family farms in the South, particularly Mississippi. A room in a boardinghouse and meals in the dining hall were part of the compensation.

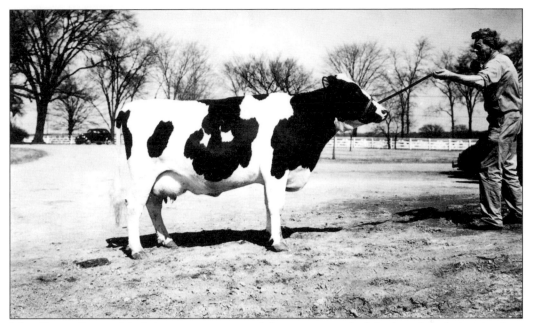

John Cuneo Sr. sent his dairy managers around the country to find the best foundation stock to begin his dairy herd. They purchased premium animals from the Carnation Milk farm and from the experimental farm at the University of Illinois. Above, one of the matriarchs of the herd displays championship bulk. Hawthorn cows set milk production records, and Cuneo adopted the slogan "Home of champions" for his dairy operation.

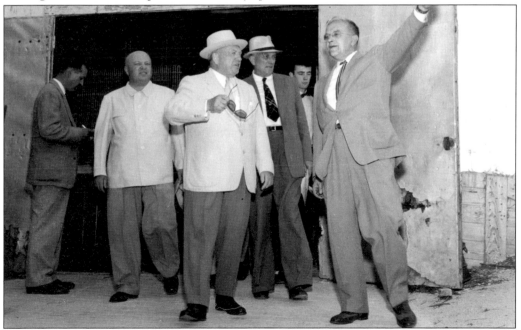

The Hawthorn operation developed a reputation as a model of modern farming. When Soviet farmers came to the United States in 1955, they visited Hawthorn Farm. Here John Cuneo Sr. (center) shows a group of Soviet visitors the dairy operation. In later years, Japanese farmers would visit the poultry barns on Butterfield Road to see the latest in egg-harvesting equipment.

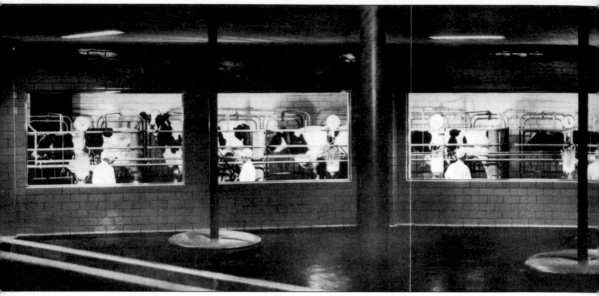

By the late 1940s, the Hawthorn Dairy maintained a fleet of trucks in Highland Park and delivered milk along the north shore as far as Evanston. John Cuneo Sr. decided to upgrade his operation by building a state-of-the-art milking barn. The milking parlor opened in September 1949 and featured a gallery for visitors to watch the cows being milked. They were milked twice a day and the panoramic photograph is the midnight milking with an empty gallery. In the new

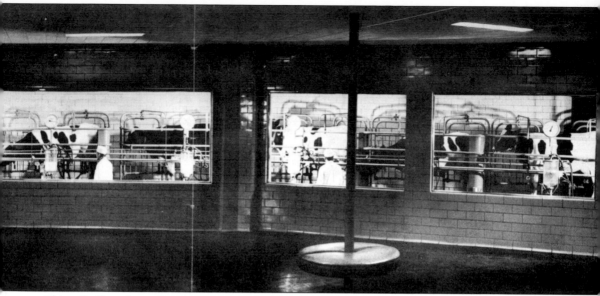

milking facility, the milk was never touched by the dairyman, but was suctioned by electronic tubes into a transparent jar on a scale. After the milk production was weighed and recorded for each cow, it was released through clear plastic tubes to a stainless steel holding tank, ready for shipment to the Chicago processing plant.

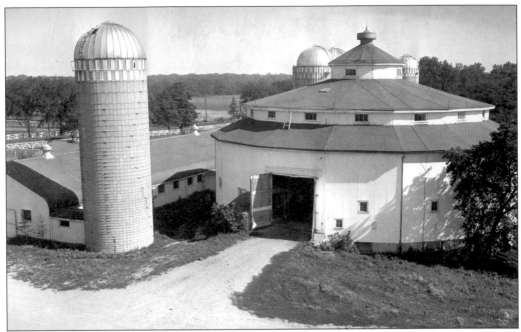

The new dairy barn and milking parlor would be built on Milwaukee Avenue just north of the Elgin, Joliet and Eastern Railroad tracks. The original round dairy barn was a little further in from the road. The white plank fencing of Red Top Farm can be seen in the background across Milwaukee Avenue. The round barn burned in 1955.

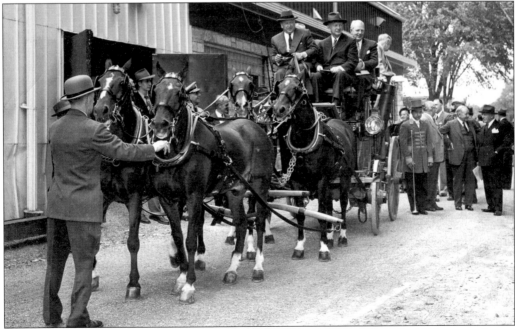

The opening of the new cow barn and milking parlor on September 17, 1949, was a festive occasion. Many of John Cuneo Sr.'s business friends attended the reception and viewed the new facilities. In the photograph, Cuneo (left on front seat) and Mayor Martin Kennelly of Chicago prepare to tour the grounds via carriage.

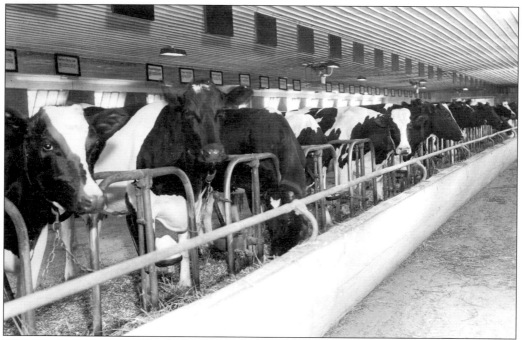

The new barn accommodated about 250 cows. The barn doors were often open, especially during hot weather, and visitors walking from the zoo to the milking parlor often stopped with their kids to see where the cows lived.

The photograph above shows Milwaukee Avenue looking south past the milking parlor. This is probably a Sunday afternoon in late spring—no leaves on the tree, but no coats on the guests. There is a small crowd at the door and the cars are parked all along Milwaukee Avenue.

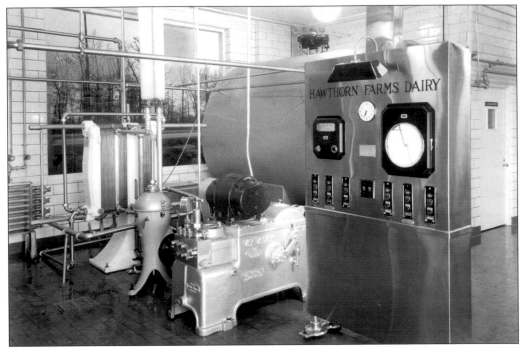

In the 1950s, Americans were becoming more aware of the importance of hygiene in food production. Clean handling was stressed in all of Hawthorn's promotional materials. The photograph above displays shining stainless steel spotlessness at the processing plant.

Two of the major themes of Hawthorn Mellody Farm are featured in this comic photograph. The emphasis on hygiene has already been mentioned as both a cornerstone of modernization and as a marketing theme. Children's tours and attractions became central to the dairy's image after 1948.

In 1948, 100 children from Jane Addams's Hull House in Chicago visited the farm. For the next 20 years, the dairy arranged for children's tours through schools and social service agencies in the city. The children were transported around the farm to see the various animals and activities. (Jane Addams Memorial Collection [JAMC_334_1053] University of Illinois at Chicago Library.)

The Hull House children watch a cow being milked at the dairy in 1948. The farmer's hats were standard issue for the day. After the tour, the children were given refreshments, including, of course, Hawthorn Mellody ice cream, at a picnic grove on the shores of Lake Charles. (Jane Addams Memorial Collection [JAMC_334.1052] University of Illinois at Chicago Library.)

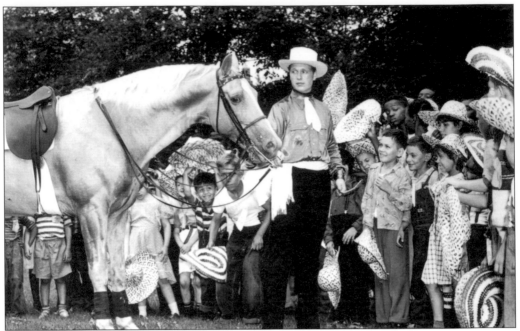

John Cuneo Jr. demonstrates some fancy horsemanship to children from the Hull House tour in 1948. According to local accounts, over 4,000 children visited the farm in the first year of the tour program. Most had never seen farm animals. (Jane Addams Memorial Collection [JAMC_334_4198] University of Illinois at Chicago Library.)

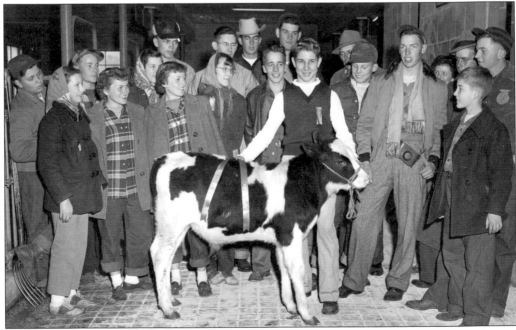

Pride beaming in his face, the winner of a 4-H contest presents his blue-ribbon calf. There is no date on this photograph, but the saddle shoes, hairstyles, and white socks probably indicate the 1950s. These are obviously not city kids; besides the organized bus tours from Chicago, local groups visited the farm as well.

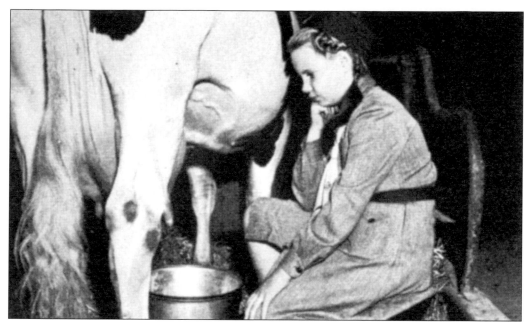

The stated purpose of these many visits was educational. American society had gradually migrated from an agricultural rural landscape to an urban setting. While it once was not necessary to teach a child that the cow says, "moo," now children were no longer familiar with farm animals, or with food production and supply. A trip to the farm allowed them to see, hear, and touch the animals, as well as to hear their guide explain farming processes. The educational blended easily with the promotional. Little Johnny was more likely to drink his whole glass of milk on Monday morning if his mother could assure him that it was from the Hawthorn Mellody cow he had seen being milked on Sunday afternoon. In this set of photographs, the Brownie learns by doing where milk comes from.

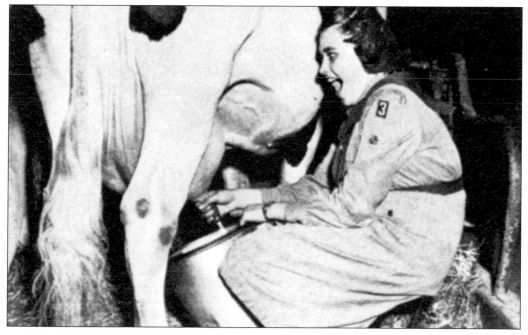

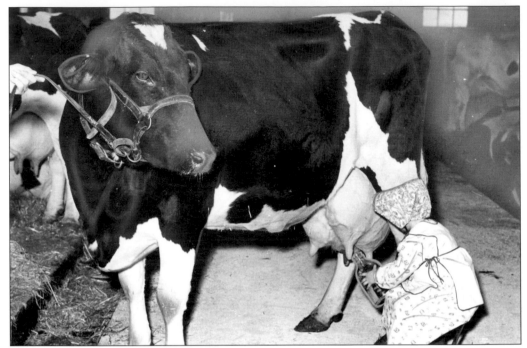

This little entrepreneur wants to combine the milking and bottling process, but the cow is not so sure. Photographers who were hired by the dairy publicist often used children of people who worked on the farm. The little milkmaid here is once again Carla Snyder, daughter of publicist Carl Snyder.

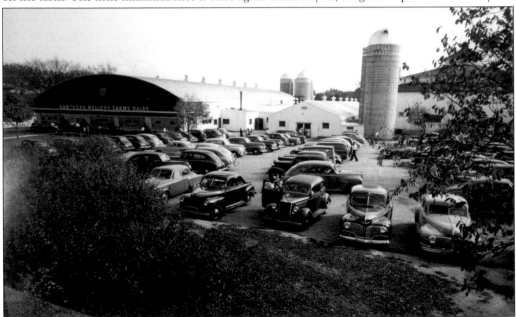

In this photograph, the space between the barns, the only area available for parking, is full of cars. John Cuneo Sr. may have originally underestimated the public response to the milking parlor, but he did not miss the opportunity to press the public relations advantage of families willing to travel 30 miles or more to see cows being milked. He began to add attractions and parking to the dairy complex.

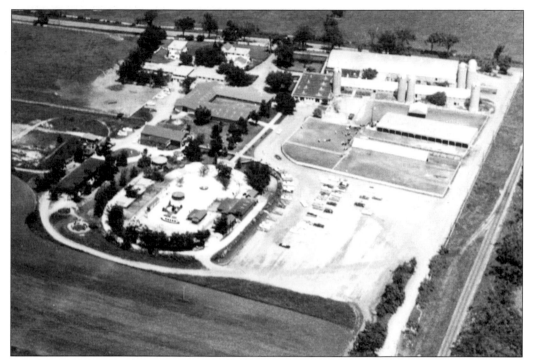

For the next 20 years the Hawthorn Mellody Dairy park was the most popular development on the Cuneo land. It was situated on the east side of Milwaukee Avenue just north of the Elgin, Joliet and Eastern Railroad crossing, visible on the right in the photograph.

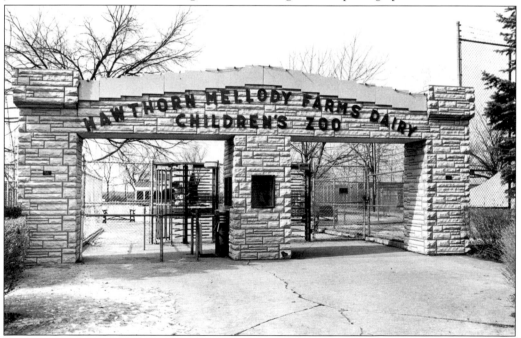

In 1951, the zoo opened its gates. It was modeled after a children's zoo in the Bronx. Built before the days of habitat replication, it was a simple oval enclosure of cyclone fencing, stone shelters and wooden barns, but it housed a respectable collection of animals from around the world.

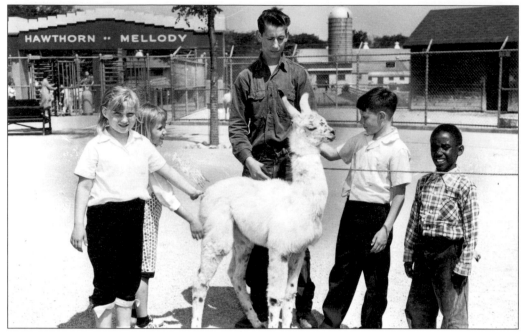

A zookeeper presents a baby llama for the children's inspection. There was a regular petting zoo circle where tamer animals were kept for closer contact with the kids. There were also lions, wolves, polar and grizzly bears, chimpanzees and monkeys, and a wide variety of birds. Entrance to the zoo could be obtained with 15¢ or the trademark daisy off Hawthorn Mellody dairy products.

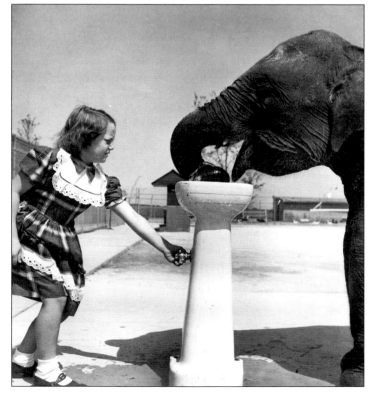

With a little help from a friend, an elephant takes a drink. Carla Snyder is the little girl in the photograph. Her confession of being terrified of the animals is noticeable in this photograph. Her pose betrays a certain wariness. (Carla Belniak.)

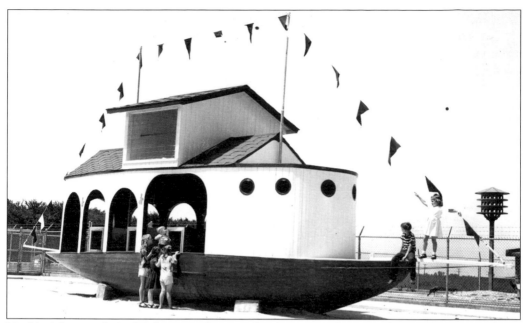

Noah's Ark was a Lake Michigan tugboat used to house small mammals. Not having anything more exotic to put in the cage on the top, the zookeepers housed a common field crow there. After viewing the animals in the bottom cages, kids would invariably say to their friends, "Let's go." After hearing the phrase repeated, the crow began to mimic the kids and he became a favorite attraction in the zoo.

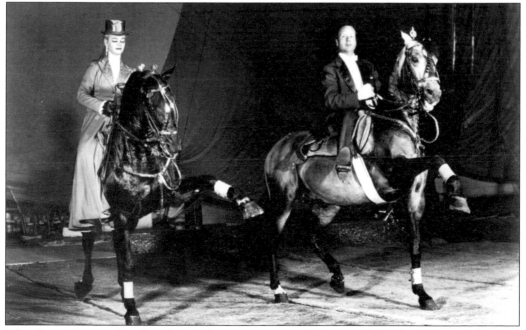

John Cuneo Jr. was placed in charge of acquiring some of the animals for the zoo. This job led to a lifelong fascination with performance animals. Cuneo started his own circus, which performed around the world. In the photograph above, John Cuneo Jr. and his wife Herta put show horses through their paces.

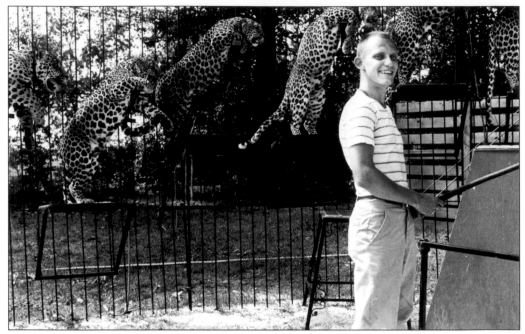

Eventually, John Cuneo Jr. built a complex in Richmond, Illinois, to house and train his circus animals. Before the new facility was built, a temporary training facility, pictured above, was built off of Butterfield Road. In the photograph, George Kufrin, a professional photographer who did many publicity shots for Hawthorn Mellody, poses with performing leopards.

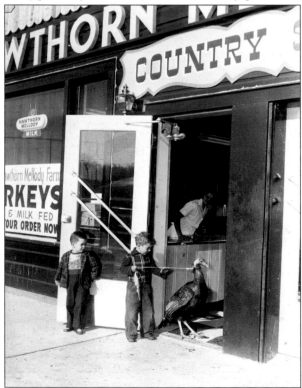

Boys persuade a turkey that the country store is not safe for him (notice the sign in the window). In 1952, Cuneo opened the Club of Champs, which at one time displayed Jesse Owens running shoes, Joe Louis's boxing gloves, and Red Grange's football jersey. Later the sports memorabilia was condensed, and the front part of the building became the country store.

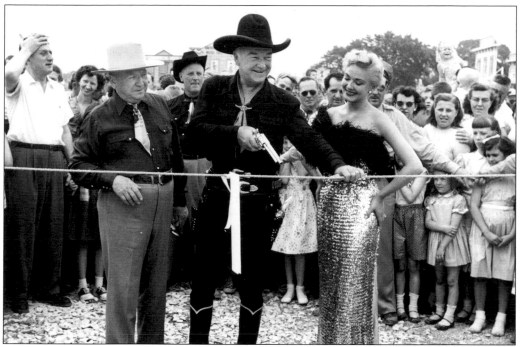

On June 19, 1955, television cowboy star Hopalong Cassidy (William Boyd) shot the inaugural ribbon for the H-M Bar 20 Ranch and Frontier Town. John Cuneo Sr. (left) in his cowboy duds and an unidentified starlet assist Hopalong at the opening ceremony.

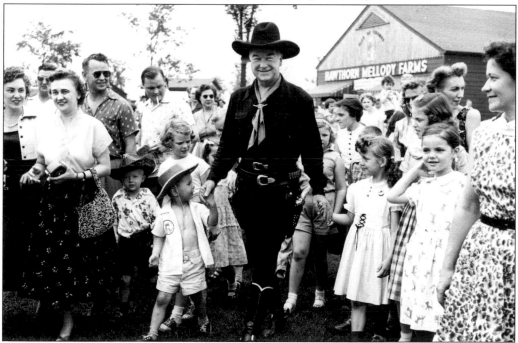

Hopalong Cassidy leads his posse of fans in front of the country store. On the day the Frontier Town opened, Hopalong's star power drew 20,000 people. Two-lane Milwaukee Avenue was clogged with traffic. He became a regular spokesperson for the Hawthorn Mellody dairy products.

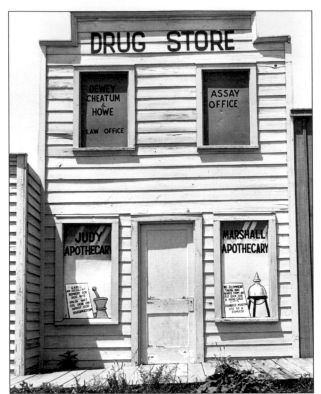

Hawthorn Gulch was meant to duplicate towns of the old west as they were depicted in popular television serials and movies. There were actually only three real buildings with interiors, the rest were painted fronts supported by struts. Visitors strolled along the plank sidewalks and read the comic announcements like those in the windows of the drug store in the photograph.

The whole Frontier Town was moved a mile to the north behind the original Hawthorn School building. This was to provide a destination for a genuine steam train ride. Visitors, like those pictured above, boarded the train behind the country store, were transported through the cornfields with cutout figures of cowboys and Native Americans on the side of the tracks, and disembarked at the Frontier Town.

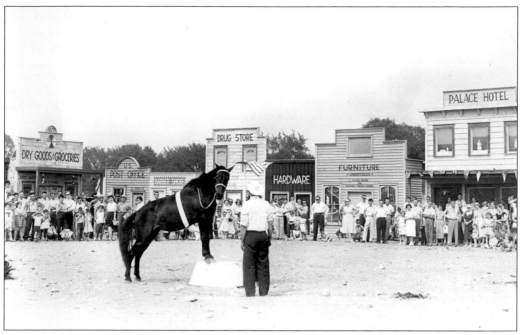

On midsummer Sunday afternoons, when the crowds were largest, entertainment was provided at the Frontier Town. Sometimes, one of the dairy workers with an ambition to be a country western singer would provide an impromptu concert. The cowpoke with the fancy horse tricks in the photograph above was a more regular performer.

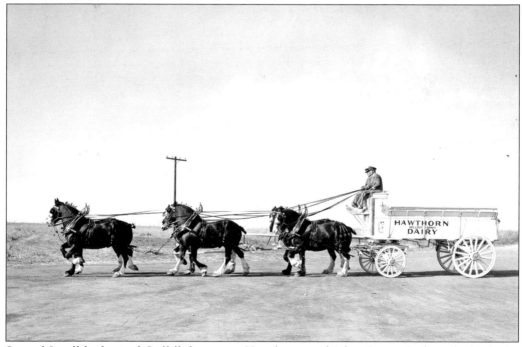

Samuel Insull had raised Suffolk horses on Hawthorn, and John Cuneo Sr. brought back the herd when he first took over the farm. Later he replaced the Suffolks with Clydsdales, which he used to pull his six-horse hitch dairy wagon at parades and horse shows.

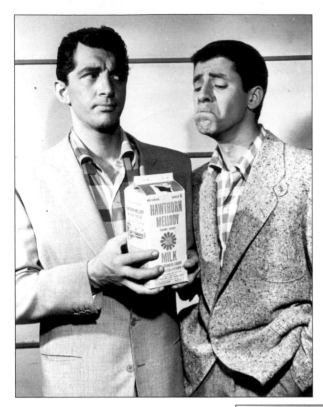

Hopalong Cassidy was a regular spokesperson for the dairy products, but Carl Snyder enlisted some other very big names from the entertainment industry. Dean Martin and Jerry Lewis posture for the camera in the photograph at left. (Photograph by George Kufrin.)

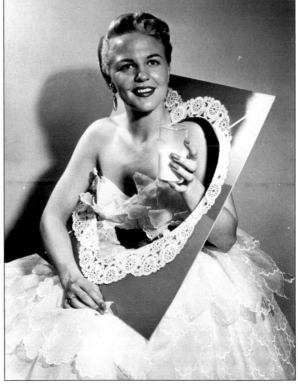

A young Peggy Lee bursts through a heart to present a glass of Hawthorn Mellody milk. When the entertainers were coming to town for engagements, Carl Snyder would arrange a brief photography session at their convenience. Star endorsements were relatively new and the fees were still reasonable. Often the star thought it beneficial to be associated with such a wholesome product. (Photograph by George Kufrin.)

Nellie Fox, star second baseman for the "Go Go" Chicago White Sox, hoists a tall glass of Hawthorn Mellody milk. Star endorsements are formally contracted by agents and extremely lucrative today, but at this stage a baseball player, acting on his own, might only get $100 for posing with a product. (Photograph by George Kufrin.)

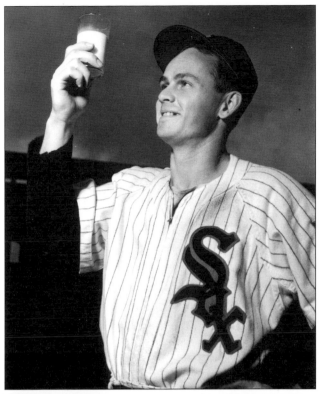

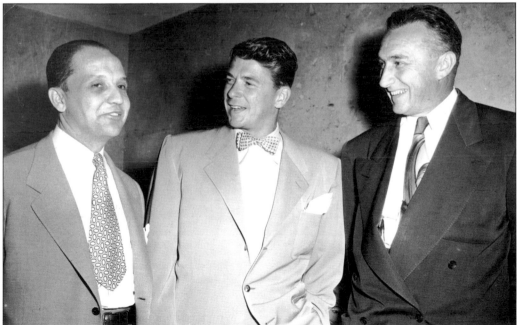

Carl Snyder was an extremely effective publicist for Hawthorn Mellody Farm products. He was able to attract big names from a variety of professions to the farm. Here Snyder (left) and Harold Peters, dairy president, flank future president Ronald Reagan, probably then in his sports announcing days.

This lean fellow was also a star of sorts who performed at Frontier Town. He perhaps foresaw the fate of Hawthorn Gulch and its inhabitants. John Cuneo Sr. sold the dairy in 1968 to National Industries, a conglomerate with varied holdings. The company ran the amusement facility for two years, but closed the operation down in 1970.

This poster announces the sale of dairy stock and equipment. The dairy business continued at its Wisconsin plant for many years after, but its corporate owners used it as collateral to secure loans and the dairy could never work its way out from under its debt. The name alone continued up until recent years in Chicagoland, but seems now to have disappeared for good.

Six

HOME IMPROVEMENTS

John Cuneo Sr. purchased the mansion and part of the Insull estate in 1937. Cuneo had married Julia Shepherd in 1930 and their children, John Jr. and Consuela, were born in 1931 and 1933, respectively. The mansion was the family home until Julia Cuneo died in 1990.

While many of the basic design elements of the mansion and grounds remained unaltered during the many years of the Cuneo family residency, there were several significant changes. Originally the skylight in the great hall could be opened on days when the weather was fine to re-create the open arcade of an Italian home's central courtyard. The Cuneos planned to place furniture in the hall and, rather than risk water damage from a leaky skylight, they had the glass permanently sealed. John Sr. added an indoor swimming pool to the north side of the mansion in 1962. A devout Catholic, he converted a sun porch into a private consecrated chapel. He hired ecclesiastical artist John Mallin to paint the ceiling and design the stained glass. Mallin returned to the mansion to paint ceiling murals in the ballroom, the dining room, and the breakfast room.

In the 1960s, John Sr. also made some changes on the grounds. He brought gardeners from Italy to redesign the area south of the mansion. Jens Jensen had installed narrow lawns with irregular contours that provided changing views of the mansion and gardens as one strolled through them. The new designers removed some of the shrub plantings to widen the lawns. In an effort to recreate the look of an Italian villa, they also placed classical statues at regular intervals.

The most significant legacy of John Cuneo Sr., however, is in the mansion's collections. The Cuneo family's Italian heritage is reflected in many of the museum's artifacts, particularly in the paintings, many from the Italian Renaissance. The collection also includes 17th century Flemish tapestries, Capodimonte porcelain, and a variety of silver pieces. The rooms are full of the accumulated treasures of a lifetime of passionate collecting by the Cuneo family.

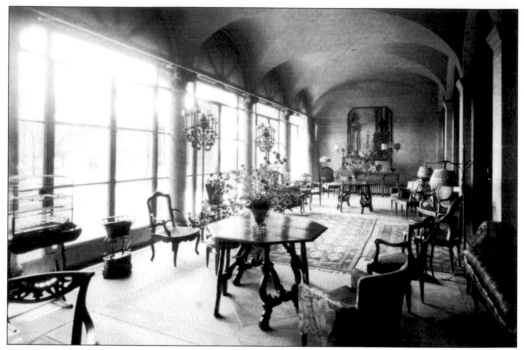

Benjamin Marshall knew, of course, that in the northern Midwest the sun is usually in the southern sky. The rooms on the south side of the mansion consist of walls of glass to maximize the sunlight. The room in this photograph was a sun porch during Samuel Insull's residence.

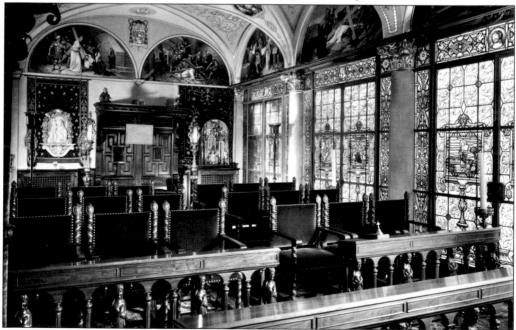

John Cuneo Sr. was a devout Roman Catholic. He wanted to convert the sun porch into a consecrated chapel. Consecration is a special blessing that prepares a site to be used to offer mass and it requires the Pope's permission. Cardinal Stritch, the archbishop of Chicago was a friend of Cuneo and obtained the pope's approval. The chapel was consecrated in 1941.

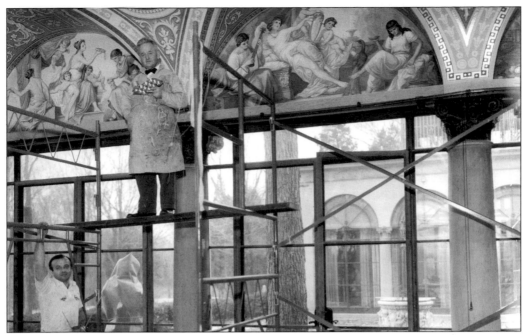

John Mallin was born and trained as a painter in Bischofwart, Lower Austria. Work was scarce, so he came to the United States and opened a studio in Chicago. He specialized in ecclesiastical painting and decorated dozens of churches in the city. John Cuneo Sr. hired him to paint the chapel ceiling, the ballroom, and the dining rooms. Here, Mallin works with his son on the ballroom.

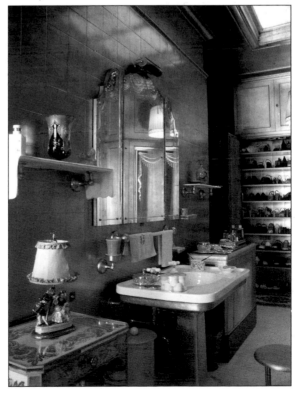

Julia Cuneo's bathroom, with its golden color, antique fixtures, and many closets, could be a set for a Gloria Swanson movie. Because Julia was the last to live in the mansion, many of her personal effects like the hatpins and perfume bottles remain on display. Notice the shoe collection in the far closet.

Before the movie business concentrated in Hollywood, there were a few studios in Chicago and John Cuneo Sr. owned shares in some of them. He had a movie theater in his basement. The screen is behind the curtain in the photograph above. The theater obviously doubles as the children's playroom.

John Cuneo Sr.'s doctors recommended that he swim for his health. In 1962, he had the indoor swimming pool added to the north side of the mansion. The walls of the pool room are travertine stone, and Flemish tapestries drape the walls. Cuneo swam here most every morning.

The sunken garden has been transformed several times over the years. The original Jens Jensen plan called for roses and featured a fountain with dancing ladies (see page 67). The spitting cupids in this photograph replaced the ladies and eventually the grassy circle walk was converted to a concrete walkway and border shrubs were planted.

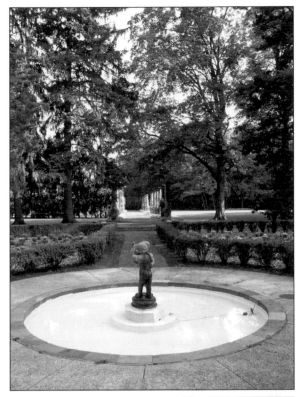

The new plant conservatory was built in the 1980s. The flowers for the gardens are grown from seed in two hothouses. The large central area is open to the public and features a stone waterfall, a wooden bridge, and stream surrounded by tropical plants.

John Cuneo Sr. filled the mansion with beautiful objects in many media from many countries. The circular porcelain table in the photograph features Madame Juliette Racamier in the center. She was reputedly the most beautiful woman in Paris in the early 19th century. The ladies in the smaller medallions on the perimeter are her rivals in beauty from the French court.

This bronze sculpture, *Trotting Horse and Groom* by Charles Marie Passage, occupied a place of honor in the center of the Italian trestle table in the great hall. Its weight began to sag the table, so it was moved to a separate stand. Despite its actual weight, the figure rests on only one of the horse's hooves and the toe of the groom, which gives the sculpture a sense of lightness and movement.

Seven

A New Role for the Mansion

In 1977, John Cuneo Sr. died at the age of 92. Julia Cuneo lived in the mansion until her death in 1990. The house and 73 acres were then transferred to the Cuneo Foundation to be run as a historic house museum.

At the direction of John Cuneo Jr., there have been significant renovations to the mansion and grounds. In the busy months before the opening, a formal garden was planted where Jens Jensen's vegetable garden had been years ago. The white fallow deer that had been a common sight along Milwaukee Avenue were moved closer to the museum, and a bird house was constructed for blue and white peacocks. Inside the mansion, the John Mallin murals in the ballroom and breakfast room have been restored. Two of the bedrooms were converted to display the Cuneo porcelain and silver collections.

Besides the physical changes, the purpose of the house has evolved as well. The mansion and grounds serve as the site of various entertainments, cultural offerings, and private special events. There have been art fairs, concerts inside and out, theater for adults and children, lectures, dances, an annual holiday light show, and classic car concourses. Hundreds of brides and grooms have celebrated their nuptials on Gladys Insull's stage and many toasts have been lifted in the dining room at corporate dinners and anniversary parties. The beautiful setting has served as a set for several commercials and two major movies. In short, the mansion continues to serve a purpose in a completely different kind of community.

While the changes are interesting and necessary, with a historical property what remains the same is essential. The Cuneo Museum preserves a vestige of the local past amid the new and crowded landscape. As visitors walk through the grand interiors filled with objects of rich, antique beauty and the quiet grounds of manicured lawns and formal gardens, they can appreciate the ambitious elegance of the gentlemen farmers who once transformed this area.

Despite the necessary financial backing of foundations, all historic house museums must raise funds to survive. Although it sometimes clashes with the preservation role, special event rental of the museum facilities allows clients to borrow some of the glamour that the owners built into the estate. Weddings are the most frequent type of rental.

The pavilion tent is used for Mother's Day brunch (pictured) as well as for wedding receptions and other types of banquets. The dining room and great hall are also rented for smaller, more formal dinner or holiday parties. The ornate elegance that impressed the guests of the Insulls and Cuneos is still charming visitors to the museum.

The museum is also an art gallery, containing a notable collection of Italian Renaissance painting, porcelain, silver, and tapestries. It is fitting that the museum has become a venue for art shows of various kinds. The Children's Arts Fair was a tradition at the museum for many years.

For the last several years, a garden arts festival has been held on the south lawn between the statue rows. Artists and craftsman working in a wide variety of media have the opportunity to show, sell, and discuss their work with the public.

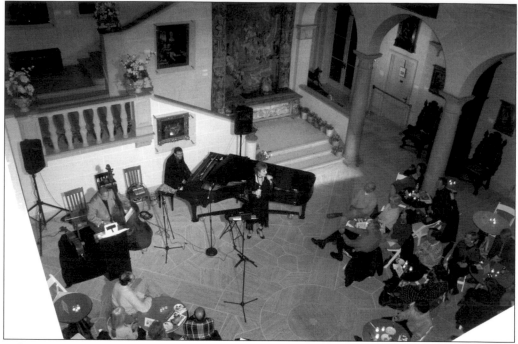

Cabaret singer Rebecca Boston heats up the great hall with a jazz performance. Architect Marshall built fine acoustics into the hall. Originally, a pipe organ was supposed to be installed for Samuel Insull. The space above the grand staircase was for the pipes. The organ was never put in, but the acoustics have served other performers well.

Sam Magdal sings a salute to Frank Sinatra at a recent concert while guests dine and dance on the lawn. If the weather cooperates, the manicured lawns, statuary, fountains, flowers, and trees make the Cuneo gardens a beautiful venue for a variety of outdoor events. (Photo by George Cook.)

Some events have become a Cuneo tradition since the museum opened in 1991. Every year the grounds have provided a suitable backdrop for a display of classic cars. For the day, the estate returns to its elegant golden years.

Actress and artistic director Paddy Lynn of the Kirk Players depicts the life of poet Emily Dickinson in one of the many theatrical production staged at the museum. The mansion has been a medieval castle for *Lion in Winter*, an English country home for *Sleuth*, and the setting for a variety of murder mysteries by Agatha Christie and others.

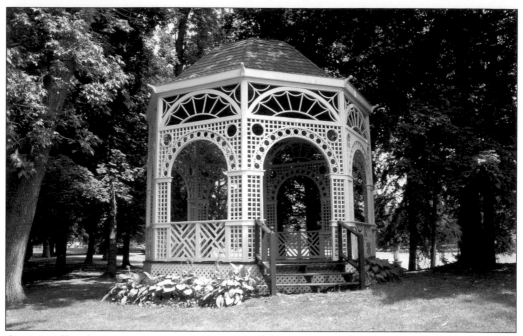

Occasionally, the mansion or grounds are used for commercials, television shows, or movies. In the gazebo pictured above, Julia Roberts received the kiss that set off a chase with Cameron Diaz in the 1998 production of *My Best Friend's Wedding*. The gazebo was the site of several subsequent weddings before it was recently torn down.

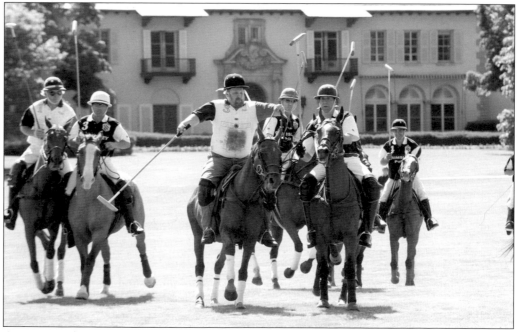

A movie with a completely different tone was shot at the Cuneo Museum in the summer of 2007. Comedian Larry the Cable Guy (Dan Whitney) was here for two weeks to shoot *Witless Protection*. In the photograph, Larry struggles against his archrival in a polo match on the lawn in front of the mansion.

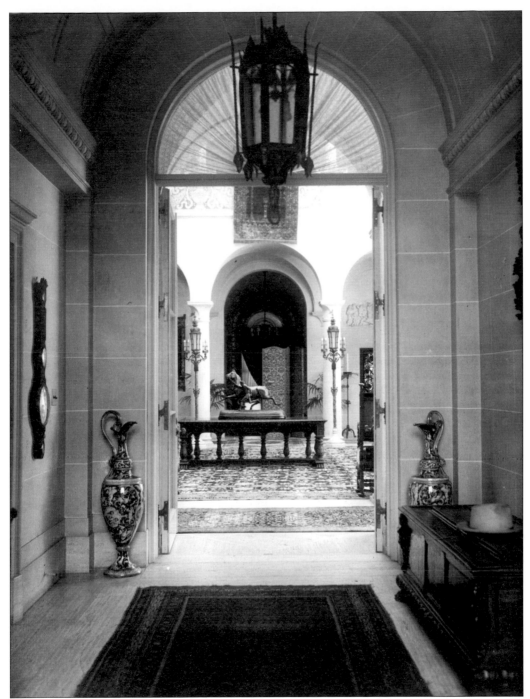

The mansion was conceived in the fancy of Samuel Insull and enhanced by the Cuneo family's additions and renovations. The museum preserves their combined vision of residential grandeur. Besides capturing and presenting to visitors this glimpse of its past, in its new role as public historic treasure, the mansion now provides a magnificent setting for weddings, plays, movies, and cultural events. The classic entryway pictured above remains open to a new generation of visitors who, like the privileged guests of the past, can savor the beauty of this elegant home.

ACROSS AMERICA, PEOPLE ARE DISCOVERING SOMETHING WONDERFUL. THEIR HERITAGE.

Arcadia Publishing is the leading local history publisher in the United States. With more than 3,000 titles in print and hundreds of new titles released every year, Arcadia has extensive specialized experience chronicling the history of communities and celebrating America's hidden stories, bringing to life the people, places, and events from the past. To discover the history of other communities across the nation, please visit:

www.arcadiapublishing.com

Customized search tools allow you to find regional history books about the town where you grew up, the cities where your friends and family live, the town where your parents met, or even that retirement spot you've been dreaming about.